A Santa Fe Legend

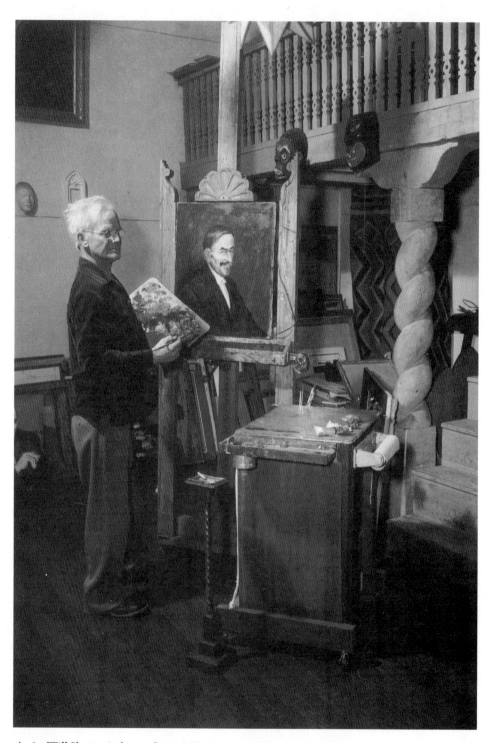

Artist Will Shuster in his studio at 550 Camino del Monte Sol, 1953.

Will Shuster
A Santa Fe Legend

by
Joseph Dispenza and Louise Turner
Introduction by Richard Bradford

MUSEUM OF NEW MEXICO PRESS

The Museum of New Mexico Press is a unit of the Museum of New Mexico, a division of the State Office of Cultural Affairs.

Zozobra is a registered trade name and copyright owned by the Santa Fe Downtown Kiwanis Foundation.

Printed in Hong Kong .

Library of Congress Cataloging-in-Publication Data
Dispenza, Joseph, 1942-
 Will Shuster : a Santa Fe legend / by Joseph Dispenza and Louise Turner.
 p. cm.
 Includes index.
 ISBN 0-89013-198-8. — ISBN 0-89013-199-6 (pbk.)
 1. Shuster, Will. 2. Artists—New Mexico—Santa Fe—Biography.
 3. Santa Fe (N.M.)—Biography. I. Turner, Louise. II. Title.
 N6537. S537D57 1989
 759.13—dc19
 [B] 88-35699
 CIP

All chapter opening vignettes are from original etchings by Will Shuster. All photographs, unless otherwise indicated, are included in the Will Shuster Archive at the Museum of New Mexico's Museum of Fine Arts.

Produced by Clark Kimball, The Rydal Press, Santa Fe.

Design and cover by Daniel Martinez.

Museum of New Mexico Press
P.O. Box 2087
Santa Fe, New Mexico 87504-2087

To the Memory of

Don B. Shuster
July 17, 1921–January 22, 1989

who made this book possible

Contents

Acknowledgments

In the fall of 1987, Clark Kimball, the publisher of the Rydal Press in Santa Fe, was contacted by Don Shuster and asked to produce a book about his father, Will Shuster. The estate of Selma Dingee Schaumann Shuster had just been settled, so at last the story of "Shus" could be written.

Clark, as project director, quickly hired us and charged us with the responsibility for researching and writing the book to be published by the Museum of New Mexico Press. Its publication would coincide with a retrospective exhibition of Shus' work at the Museum of New Mexico in the fall of 1989, and with the annual Santa Fe Fiesta and the burning of Zozobra. The latter were the community events long associated with Will Shuster—events so beloved and influenced by the popular Santa Fe artist.

We delved into the research—the many interviews, pages of letters and diary entries—and met often with the Shuster children: Don Shuster, John Adam Shuster, and Linda Shuster Marts.

Throughout the project, we were guided by their conviction that "people would want to know about Shus," and encouraged by what they called "a free hand to tell the story as we saw it." The book owes much to their generous participation.

Don, in particular, perhaps as the eldest, took the lead in availing himself and his memories of his father to us. Don passed away before the book could be published. It is with sadness and a real sense of loss that we acknowledge his passing. His is survived by his wife Helen; children Don, Jr., Tom, Paul, and Mark; and his brother John and sister Linda. It is to Don and the Shuster family that we dedicate this book with appreciation.

We also wish to acknowledge with our thanks the following who helped with this book: Santa Fe Downtown Kiwanis Club, Spencer Kimball, Santa Fe Police Department, Dolona Roberts, Damian Andrus, Elizabeth Knee, Eric Knee, Duane Northup, Bill Lumpkins, Jann Arrington Wolcott, Harold Gans, 'Gonzo' Gonzales, the Delaware Art Museum, Dorothy Dingee, Chuck Barrows, Amos Melendez, Lorencita Abeyta Rael, The Museum of New Mexico and its publication unit, especially Director James Mafchir, Chief Editor Mary Wachs, and Designer Daniel Martinez; Sandra D'Emilio, curator at the Fine Arts Museum, and David Turner, Director; Margo Shirley, Santa Fe Fiesta Council, Tom McCarthy, Walter Wright, Robert Nugent, Marion Love, John Pen La Farge, Calla Hay, Dale Barber, Dee Seton Barber, Bambi Ellis, Helen Farr Sloan, Tony Martinez, Mrs. Irene Walker, Ronald J. Francis, Louise Tomatzu, Gerald Peters Gallery, Jerry West, Mariam Davis, Joseph Valdez, Rina Swintzell, Jacques Cartier, Buzz Bainbridge, Tom L. and Jane Larsen, The Peters Corporation, Bud Hilker and the Harmsen Collection, Mrs. S. Glidden Loomis, Incienso de Santa Fe, Charlotte Jacqueline Stone, The Great Southwest Books, and the Santa Fe *New Mexican*.

Joseph Dispenza
Louise Turner
Santa Fe, 1989

Introduction

by
Richard Bradford

Of course I had heard about Will Shuster long before I met him. He had figured in my parents' lively, though often spurious, Santa Fe anecdotes for years, and from their gaudy narratives I had fashioned a picture of him: large, brawny, blond, but nevertheless artistic; a Wagnerian hero wearing a beret and a paint-daubed smock; a Teutonic Gauguin.

My mother and father, newly returned to Santa Fe after World War II, drove me one spring afternoon to a party at Shus' homestead northwest of town, to that stretch of country now under intense real estate development but then known simply as "way out there, someplace."

It was 1946, and I wasn't ready to accept a word like "homestead" without an argument. I'd read about homesteads in school: a homestead was 160 acres of unimproved public land, given by a grateful government to gallant veterans of the French and Indian Wars (or something), provided they build a cabin on it and raise some barley. At the very least it was an antique, obsolete word, and I knew that no people living could be involved directly with a homestead any more than they could have owned a fief with serfs on it. But Shus' was a genuine homestead, in fact, acquired under the rules of the Homestead Act, adorned by a modest and straightforward adobe house containing a number of adults behaving only moderately badly.

This was the first "grown-up party" I'd been to in Santa Fe. I had been living there for more than a year, but I'd frittered my time away hanging around junior

high school. Now that my parents were back in town, I had a chance to observe the artistic life of which they had so often spoken—the high-altitude, piñon-scented Bohemia.

Shus' party was both eye-opening and disillusioning. My memory of it may be a bit skewed because of the haze of time and the adolescent infatuation I developed for one of his guests, but I can recall the general outlines.

There was a beautiful woman at the party, an absolute knockout, with whom I fell immediately in love. I was thirteen; she was in her late twenties, married, with three children. She was the object of my first real passion, except for Ingrid Bergman, but then I'd never actually *met* Bergman, and this lady was sitting there right before my eyes. I decided instantly that I was going to spirit her away from Shus' homestead, declare eternal, chaste, medieval affection, write poems to her eyebrow and her tiny foot, slay a couple of dragons, and in general spread embarrassment and dismay. All that held me back was that I had a total fortune of seven dollars and didn't know how to drive a car.

Another of Shus' guests that afternoon was his great friend John Sloan, another painter I'd heard of, not merely through family anecdotes but in my sporadic studies of art history. John Sloan—the Ashcan School. I could have been no more dazzled had I met Manet or Degas. My mother had told me once that John Sloan was the handsomest man she'd ever seen, excepting possibly Lord Louis Mountbatten, and that she had once inveigled Sloan into inviting her to his New York studio to "show her his etchings." Much to her disappointment, she said, he'd shown her his etchings.

Sloan was a mythic figure in Santa Fe art history, too, but now he seemed much reduced—thin and frail-looking, very quiet, moving in a cautious, deliberate way, as if he might shatter. His friends at the party were careful to treat him nonchalantly, with none of the solicitousness he would have found so wounding to his self-esteem.

I met Wyatt and Mariam Davis for the first time at that party. Wyatt, a distinguished photographer, remained by himself, off in a corner, strumming a guitar with much verve and little skill. Wyatt, it turned out, was one of Shus' oldest and closest friends in Santa Fe, which may explain the host's genial tolerance for Wyatt's lack of virtuosity as a guitarist. Mariam seemed to be angry about something that evening, but I was later told that she was merely showing the Armenian fire for which she was noted, and it was not to be taken personally.

Shus' next-homestead neighbor, Jo Bakos, was also in attendance, looking very much like a colonel of the Polish Imperial Cavalry—large and ruddy, with a snow-white crewcut and a flamboyant mustache. I didn't know at the time that Jo was, like Shus, one of the five artistic pioneers of Camino del Monte Sol—Los Cinco Pintores—or that he was Shus' neighbor in town as well as in the country. Indeed, as he spoke almost exclusively that afternoon of the grace and beauty of cattle, particularly bulls, I assumed that he was an immigrant rancher.

Finally, there was the host himself, and very unSiegfriedian he was, too. The picture I had formed was false: Shus' forebears may have been Germanic, but he looked nothing like a Wagnerian *Held*; he looked more like a leprechaun.

Shus was perhaps five-feet seven, wiry, tanned, grinning, *funny*. His hair was done (if that's the word) in a windblown, Albert Einstein coiffure—a kind of mad-scientist arrangement that never varied as long as I knew him. His blue eyes were magnified by wire-rimmed glasses. He spoke with the remnants of what I suppose was a Pennsylvania Dutch accent, coming down heavy on the *g*s and *d*s. He was *noticeable*, even to an adolescent boy who had just that minute fallen in love with an unsuitable older woman and had eyes only for her.

A youngish married couple at the party (I wish I could remember their names) had one of the most colorful, *personal* domestic squabbles ever witnessed in northern New Mexico. It gave me a brand-new outlook on wedlock.

Someone else began reciting limericks.

Shus himself, who had somehow come into possession of two army surplus artillery shells (live rounds, so far as I could tell), designed a competition of strength among the men and some of the more sinewy women. The point of this inane contest was to determine who could hold a shell in each hand, at arm's length, for the longest time. Shus won the contest, of course: nine minutes left hand, eleven minutes right hand. (He'd probably been practicing for weeks.) I was impressed; he didn't look that strong. I would have been more impressed, of course, if I hadn't been so absorbed in Helen of Troy.

Shus even managed to recite a limerick while straining to keep those heavy artillery rounds aloft, something about Titian and rose madder (or, as Shus pronounced it, *rose matter*). Titian's name, spoken in the bawdy context of Shus' verse, was the evening's only allusion to art.

As we left, Shus said to me, "Kottammit, Richard, it's nice to meet you after all this time. Keep working on that left arm. I'm sure you can do better than forty-eight seconds."

Later that summer, before we left Santa Fe to return to our home in the South, my parents volunteered my services to Shus in the construction of the 1946 Zozobra, the giant, flammable puppet created by Shus in the 1920s to add a little public gaiety to the insufficiently cheerful Santa Fe Fiesta.

About twenty people were engaged in fabricating this hideous object when I turned up at the site near the old ball park (now Fort Marcy Park), and they were managing to bring some kind of artistic order out of a chaos of wood, muslin, paper, and straw. I pitched in with enthusiasm—hammering nails in crookedly, tripping over tool kits, stepping in the paint, binding the saw—until Shus realized that he was being aided by someone with gross deficiencies in carpentry. As he had lived most of his life around artists and craftsmen, Shus was at first unable to comprehend that I was completely innocent of manual dexterity and that I represented an actual danger to the project; but seeing that I genuinely wanted to help, he set me to stapling together small pieces of fabric

which, I now believe, had no place in the finished article. It was my first WPA job: I thought I was doing something useful; he got me out of the way without damaging my feelings. He even thanked me for my assistance, an act of kindness if not of rigorous sincerity.

Before I left that afternoon, I thanked *him* for giving the party at which I had met the Girl of My Dreams. He looked at me searchingly, to see if I was kidding, and then began to chuckle. "Well, kottammit, boy," he said, "good luck."

On my annual summer revisits to Santa Fe for the next few years I saw little of Shus; he was busy painting and I was busy with old friends from eighth and ninth grade, some of them girls, who now seemed even more interesting than the inaccessible paragon I'd met at Shus' homestead. But I saw a lot of him in 1954.

In the Marine Corps I'd contracted camp jaundice (now fashionably referred to as "Hepatitis Type-A") and after a few months in a naval hospital I'd been sent home to Santa Fe for a month of convalescent leave. On September 1, the opening day of mourning dove season, Shus turned up at mother's house and demanded that her torpid and sissified son stop loafing about "like a Matisse odalisque" and join him on a dove shoot in the Cochiti bosque. When I pointed out that my legs were wobbly and the rest of me no sturdier than eighteenth-century Venetian glass, Shus began to bellow at me. "I've been in those kottamm military hospitals too, boy! They almost killed me! You got to get up off your keister and move around! How do you expect to defend your kottamm country if you're too weak to pick up a gun?"

I protested that I was too fragile to stomp around in the Rio Grande bottoms, but he pointed out that he was a hundred years old (he was in his fifties) and had already spent an energetic morning putting Zozobra together.

So that day, and almost every day for the next three weeks, he dragged me off to the great outdoors. At first I simply followed him around while he blasted away at the fast, tricky little birds, and I had to rest every hundred feet or so. Later, as my strength returned, we walked for miles through muddy fields of Cochiti bee-weed, making lots of noise (we talked more than we shot) and having an amiable, strenuous time of it. I was physically ready for anything when I went back to duty; fortunately, the marines had nothing for me nearly as arduous as those weeks of slogging through the bosque with Shus.

It was on one of these forays that he recounted an autobiographical narrative ideally designed to spur me on to quicker recuperation. I am still convinced that there are elements of truth in it, although it's almost too shapely to be entirely free of romance and what Huck Finn called "stretchers." But true, false, or shamelessly embellished, here it is:

When Shus got out of the Army after World War I, he was dying. He'd been gassed (mustard or phosgene) in France, his lungs were in tatters, and he'd developed tuberculosis. He hung around Philadelphia for awhile, coughing and growing punier, until his private physician sent him on his way so that he would

not add to the depressing statistics of the East Coast's war dead. He was given a maximum of six months if he stayed in the East and perhaps a year if he moved to the Southwest, where the ambient air (it was then thought) was somehow beneficial to bad lungs.

So Shus took himself to the great American Southwest and to Santa Fe in particular, lay quietly in bed breathing in woodsmoke, chamisa and juniper pollen, burro dander and other therapeutic agents, and waited gloomily for the end.

After six months of feeling progressively awful, he decided not to wait for the full year of remaining life but to help the end along. Overt suicide, however, was out of the question, he said. There was the unacceptable matter of dishonor attached to it and of humiliation to his family. So he devised a plan.

Physical exertion, his doctors had said, was lethal to anyone in his precarious state. With this warning in mind, Shus crawled out of the bed in his tiny house, rented on a week-to-week basis—"I wasn't signing any leases in my condition"—and set out to exercise himself into an early grave.

He hiked out into the foothills every day, not expecting to return. Some days he could walk fifty or a hundred yards before he had to sit down and rest and cough for an hour. Some days he could barely make it to his gate. But he persevered. After three months of determined walking, he was managing a few miles a day. He didn't feel any better, of course, but he was alarmed to note that he didn't feel any worse, either.

After six months, when it was supposed to be time for his funeral, he could climb to the top of Monte Sol without getting winded. He began to take overnight hikes, carrying his portable easel and paints and a blanket and a can of beans. He'd hike up into the Sangre de Cristos or over to the high mountain villages and paint aspens and streams and religious processions, and then hike home after a few days of vigorous activity, feeling increasingly hale. He stopped coughing, he put on weight, and he realized that he wasn't going to die any time soon unless he got hit by a bus.

Eventually, he telephoned his doctor back in Pennsylvania, looking forward to the conversation—("You kottamm quacks don't known anything! I feel like a million bucks!")—but when the connection came through, the secretary told Shus that the doctor, unfortunately, had died.

It took years for me to realize that Shus was a leading citizen of Santa Fe, a sort of lively public monument, known to and beloved of thousands of people. There was absolutely nothing about his demeanor to suggest his status—none of the gravity that afflicts the pompous and self-important, no sham, no ostentation.

In the 1940s, Shus had been a founder of an informal men's club called Quien Sabe?, whose members met once a month to eat, drink, and talk—scruffy artists and writers, mostly, with a scattering of other professionals. Over the years the dinners had become more fancy and elaborate, the wines more vintage, and

the dress more stately, until the evenings had taken on the form of the annual meetings of the Chevaliers de Tastevin or the French Academy.

When it became Shus' turn to host the dinner, he swiftly brought the club back to its roots: On an open fire in his backyard he cooked a crude (but delicious) slumgullion in an ancient iron pot, served it in #8 tomato cans, and accompanied it with boiled camp coffee in tin cups. Some of the guests loosened their ties for the first time in years, argued frankly and noisily with each other, and got into fistfights, which was, after all, the club's original purpose.

Over the years, my mother managed to collect three Shuster works, buying them directly from the artist on the layaway plan. One was a splendid painting of a Cochiti Pueblo man and woman in corn dance costume, kneeling before a santo; one was a charming harbor scene, painted in Port Isabel, Texas, where Shus and his wife, Sami, frequently spent the winters; the third was a saucy nude reclining in a glade and smoking a wicked cigarette as several lewd Nubian goats leered at her from behind the shrubbery—Susannah and the Elders. The nude was bequeathed to a friend; the Port Isabel painting was destroyed in a fire; the magnificent Pueblo Indian scene was stolen from me fifteen years ago. I am now without a Shuster painting and will probably, sadly, remain so.

But infinitely sadder, I am without Shus himself, and so are his family, his uncountable friends, and the people of Santa Fe. Nothing remains but the years of warm and happy association with that delightful man, and the noisy hilarity of Fiesta skyrockets, every September, when Zozobra groans and roars in flames to banish all gloom.

A Santa Fe Legend

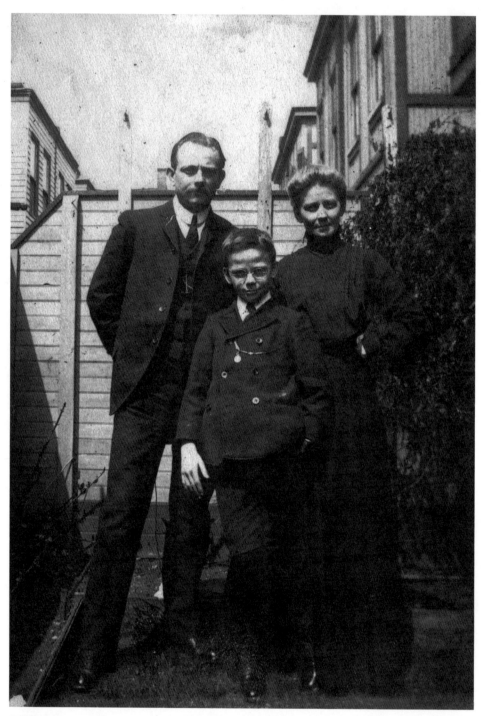

William Howard Shuster, Jr., age nine, with his parents Lizzie Steck and William Howard Shuster, Sr. in his Philadelphia birth place, ca. 1900.

∾ 1 ∾
The Early Years

I paint because of the happiness of those moments of work in which I am building a new thing. The best painting is not only the matter of a pair of eyes and a hand at work, but it is the accomplishment of a pulsing, vibrant being in the finest of tune—having a wonderful experience, a fine time. It is this ecstatic state which produces the things that surprise and startle even the painter. I often look at my paintings in idle, contemplative moments and wonder how in the devil I did them.

—Essay, 1920s

W illiam Howard Shuster, Jr.—"Will"—was born on November 26, 1893, in Philadelphia. Shuster stock in America went back to 1810 in Germantown, Pennsylvania, which was then a separate settlement near the Quaker City.

In the last decade of the century the Shusters of Philadelphia were a comfortably well-situated middle-class family. William, Sr. was by trade a hat maker, which put him in touch with a wide circle of citizens, noble and ignoble, in the bustling and gentrified City of Brotherly Love.

It was there at his father's side that young Will might have awakened to the notion that one's life could be spent making useful things with one's hands. Early on he enjoyed a well-deserved reputation as inventor and fixer of things, youthful talents he would take with him into adulthood.

His early boyhood was not unlike that of a young Huck Finn or Tom Sawyer.

Canoeing and swimming expeditions on the Delaware River with his friends were favorite summer pastimes. His Grandfather Steck on his maternal side was a fun-loving, mischievous gentleman who assisted the young Will in getting into mischief himself, much to the consternation of Will's mother. The beloved Steck patriarch was known for his sense of humor—a characteristic that the young Will undoubtedly inherited from him.

Will's friendships with his boyhood chums endured through adulthood, and several visited him in Santa Fe after 1920 when he moved to the small southwestern community. Unhappily, Will's own father never visited him in his adopted city. Because Will ultimately chose the artist's life for himself, a rift developed between father and son that was never entirely resolved. The son's chosen profession was unacceptable to the father, whose values were solidly middle class. To the elder Shuster, the artist's life was analogue to prostitution.

Though he had numerous opportunities to return east for visits, Will Shuster let seventeen years elapse before going back to Philadelphia in May 1937. Nine years later Shuster made a painting excursion to New York and spent a week with his ailing father. When the elder Shuster died in September 1947, Will made a third trip home—his last. He split his one-week stay between Philadelphia and New York, where he spent whole days in the art museums looking at paintings.

For Shuster, life seemed to begin, as it did for many of his generation, when he went away to fight in the Great War. And it continued, gloriously, when he decided to move from the East to the untamed wilderness of the American Southwest.

The War was an ordeal that he was never able to set aside. It haunted him down the years like a ghostly physical presence. Disabled in the trenches in France from inhaling toxic mustard gas, he became philosophical about mortality. Then came years of another conflict, this one with the Veteran's Administration for some appropriate financial compensation.

None was more patriotic than Will Shuster, as a cursory glance at his writings, public and private, testifies. But he was also mightily fair-minded. When his claim to disability was contested by the bureaucrats in Washington when he returned home, he set himself with a fury to obtaining a modest monthly income for himself and his wife and children.

Later, when his two sons went to war—Don to World War II and John to Vietnam—Shuster sent them off with a paternal ambivalence of vast pride and deep apprehension. He would not deny them their experience of personal courage, but he hoped they would be spared the long aftermath of physical injury and its attendant volleys of affidavits and certified proofs.

Santa Fe represented a new lease on life for Shuster. In fact it was where life truly began for him. Out of impending physical danger he at last drank in the great freedom of the wide open spaces. A bohemian lifestyle was possible where

few social constraints interfered, and Will embraced it with an exuberance that was infectious.

In his journals and in letters to his close friend and artistic mentor John Sloan, he is rhapsodic on the subject of his adopted home. On one of his rare excursions out of town he wrote Sloan that he was feeling homesick for the adobe town:

> I too wonder about the attraction of Santa Fe, but damn it, it has something. I have had touches of nostalgia several times. Perhaps it is the sunlight, but there is no question about the fact that there is a great pull. I am more inclined to believe that it is the stimulation of the extremes—in every direction—that we experience there which we miss when away from it.

The ancient cultures of the Indians and the colorful descendants of the Spanish settlers struck him as exotic and wonderful. And he found in the landscape, with its extremes of climate and its otherworldly beauty, an infinitely rich stimulus for his growth both personally and as an artist.

He had not planned on being a painter. In Philadelphia he had taken art lessons and painted avocationally. Once in Santa Fe, however, encouraged by Sloan and others who formed the more-or-less permanent art colony, he blossomed at the easel.

Surely part of his decision to pursue the life of an artist was inspired by his deep appreciation of New Mexico's canyons, valleys, towering peaks, and vast empty spaces. To his artistic sensibility the landscape seemed to say, "paint me." It all was unimaginably romantic, and, for a spirit ready to live life to the fullest, irresistible.

The romance of Santa Fe was for Will Shuster in the land, which spoke of freedom, and in the people, both native and transplanted, who dwelt in its radiance. He gave himself to its spell with an abandon that brought forth an endless flow of creative energy for him to apply to his art, and even more especially, to his life.

❋　　❋　　❋

Will Shuster was the middle child of his family. Ellie Mae, a sister, was born and died before Will was born; she lived only a year. Stephen arrived three years after Will, and died of blood poisoning in 1904 as the result of a sledding accident a year earlier. Growing up virtually as an only child did not seem to make any perceptible difference in young Will's personality; he had, in any case, an independent bent in the family setting. There is a strong Horatio Alger sensibility to his early years. It is reported that he excelled at school, though he was never at the very top of his classes.

Of medium height, on the slender side, bespectacled, he cut an attractive figure as a vital youth. From the beginning he loved experimenting with things. He

had the curiosity of an inventor and the native mechanical ability of a born engineer. Radio was a particular passion for Will. Sometime during his years at the Manual Training High School in Philadelphia he and his future brother-in-law, Joe Hasenfus, built the most powerful amateur radio transmitter and receiver in the city. Once they picked up and relayed to authorities an SOS that no one else had caught, thus enabling a foundering ship to come home to safety.

Elated with this success, the talented boys conceived the idea of a radio-controlled cannon. The apparatus was successful, unfortunately, when they blew a hole in the roof of the Shuster house. (One wonders whether Grandfather Steck was a co-conspirator in the caper!)

Out of high school Shuster enrolled in Drexel Institute of Technology in Philadelphia, the highly regarded private school of the arts and engineering, majoring in electrical engineering. After a year, though, the academic regimentation wore on him and he decided to strike out directly into the job market. By luck he found himself a position at the prestigious Curtis Publishing Company.

Curtis, which published the *Saturday Evening Post*, among other periodicals and books, set Will to a task for which he was well prepared by both background and temperament—he was asked to look into the question of efficiency and to recommend ways the company could streamline its operations.

He thus became one of the pioneers of efficiency studies. Part of his assignment was simply to observe the daily routine of all aspects of the business. He made copious notes on every activity in the Curtis company, from how long it took a secretary to type a business letter to how many flights of stairs a copy editor had to ascend and descend while working on a story. Out of this he made valuable suggestions, which Curtis then used to cut waste and operate with more economy.

It was a formative apprenticeship for Will. Years later his children would remember that he organized his life extremely well and made everything at hand work for him in a given situation. He never called in a "professional" when a piece of machinery had stopped functioning; he seized the moment as an opportunity to create what was necessary by understanding what specific work the machine was supposed to perform in the first place.

During the Santa Fe homestead days in the 1930s, for instance, he developed a highly efficient system for collecting rain water that supplied all the drinking and bathing needs of the household. The expert ways he later managed human labor on his many civic projects were no doubt also outgrowths of the years at Curtis Publishing.

Efficiency was actually a manifestation of one of Will Shuster's most salient traits—self-sufficiency. It was in the spirit of independence and self-reliance that he took on all of life's adventures, whether it was rolling up his sleeves to fix an automobile that wouldn't turn over or setting out for an exotic, faraway land in the mountains to start a new chapter in his personal history.

Shuster's interest in creating was not limited to one field. A modern-day Leonardo, Shus created pictures, houses, exquisite items of wrought iron, pageants, costumes, custom-made vehicles, radios, weapons, effigies, cisterns, etchings, life masks, sculpture, and furniture. Like Fourth of July fireworks, his creativity effervesced, often sparked by his perception of a problem that needed solving and sustained by the need to create simply for the love of it.

It was in the dual spirit of self-sufficiency and creativity that it occurred to him in 1950 to concoct a mixture of sawdust, oils, and other ingredients to make piñon and juniper incense to reproduce the scent of the Southwest. He developed from scratch the ingredients of the incense pellet and designed the machine to form the pellets. He then single-handedly built the machine, including making the required castings. He also designed and illustrated the package, which still bears his name and design.

In April 1917, when the United States entered the Great War, Will immediately dropped his job at Curtis Publishing and joined the reserves. By August 15 he had been appointed second lieutenant in the U.S. Infantry.

No sooner had he signed into the military than he was inventing again, this time with designs for a rifle grenade—a rifle that would launch a hand grenade and send it hurtling behind enemy lines. The army decided not to manufacture the rifle, but the correspondence back and forth between the military higher ups and Shuster, and between various departments of the U.S. Army, shows that it was seriously considered for some time.

On the personal side, Will's romantic involvement with Helen Hasenfus, Joe's sister, had blossomed into a full courtship. Like many young people who feared the war and foreign service would endanger their relationship, Shuster and his sweetheart decided to marry.

The wedding took place in the cold January of 1918. Four months later the inevitable came to pass: Will was promoted to first lieutenant and was assigned to combat duty overseas.

What happened in France is best told in his own words, from a document he filed with the Veteran's Administration fifteen years after the events, in support of a claim for himself, his wife, and his children. It is some measure of its indelibility on Shuster's mind that he was able to recall the episode with such clarity, as if he had been wrestling with these details all his adult life.

On the eighth day of August in 1918, while serving as a first Lieutenant with Co. L of the 314th infantry at Gilley, France, I received orders to report to Lt. Col. George A. Wildrick at G-3, Headquarters 79th Division to serve as Assistant G-3 on the Headquarters Staff. . . . My specific duties were the organization and command of the Division Message center.

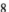

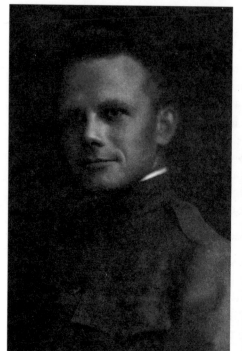 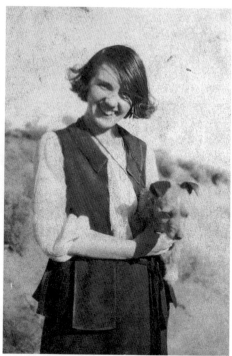

From left: Lt. William Shuster, U.S. Infantry, 1917, before assignment to combat duty overseas. Will's bride, Helen Hasenfus Shuster, with dog, Teddy, upon arrival in Santa Fe in 1920.

I served with this unit all during the first phase of the Meuse Argonne. . . . September 26th inaugurated our offensive. . . .

As I recall this offensive, it consisted of long, tense, sleepless and busy hours with no food but emergency rations, water from shell holes; and I can recall one exhausted moment in the Division Message center near Fayel Fme., which had been a German grenade depot, drenched to the skin from heavy rains, sleeping, sitting in a dugout in about eight inches of water, and later the long wet drag back to the Division Headquarters assembly point at Juoy en Argonne.

From there the division moved to Sector Guynemer, the division P.C. being first established at Dugny and then the advanced P.C. moved to Vacherauville.

It was at Vacherauville where I am certain that I received the injury to my lungs which was the point of origin of the pulmonary tuberculosis from which I have since suffered, as previous to that time, in spite of the varying hardships, I seemed to be in good physical condition. My declaration of the events preceding, my duties, the actual injury and subsequent effects, follows:

It was early in November, 1918; I had been ordered . . . to take the daily Operations Report and other communications to our rear P.C. at Dugny for forwarding to Corps Headquarters passing through Glorieaux outside of Verdun; that day we encountered shrapnel and heavy gas. . . .

On my return to the division P.C. I found that in my absence the enemy had heavily shelled the P.C. with mustard gas and that a large number of the head-quarters personnel had been evacuated. Those of us who remained went about the duties of headquarters wearing our gas masks. All due precautions were taken. The blankets making the gas locks to the dugout entrances were kept wet. Chloride of lime was sprinkled over the shell holes in the vicinity of the trenches and dugouts and after a time the air seemed to clear.

The following morning, a bright sunny morning, caused a great deal of free gas to again be liberated. Practically all of those on the headquarters staff suffered from the effects of the gas. I can recall half-closed, swollen, bleary eyes, sharp coughing and slight burning under the arm pits and in the crotch. I, too, suffered this same condition. However, the duties of message center, the gather-ing of material and the preparation of the daily operations report, the almost innumerable military duties of the headquarters staff, had to go on, and I don't believe a single one of those who were left even reported to an aid station for treatment. That was the beginning of the change in my physical condition. I never did recover from that biting cough.

After the Armistice, Shuster was left behind in the muddy, cold trenches of Vacherauville with a few men to cover any pending business in the area that had been evacuated. He remained "in that God-forsaken muddy hole" until after Christmas 1918, after which he was ordered to rejoin division headquarters at Souilly.

It was at Souilly that he suffered a general physical breakdown. A camp doc-tor diagnosed Shuster's condition as acute bronchitis and treated him there. By February he had recovered sufficiently to be granted a fourteen-day leave, which he spent happily in the south of France.

His young wife Helen was waiting when he arrived home in the States in the spring. He went on to Fort Dix in New Jersey, where he received what he called "a very cursory physical examination," and was discharged on May 28, 1919.

Back in Philadelphia he felt his health sliding down again practically to the point it had been in France. The hacking cough and a shortness of breath were constantly with him, in addition to a susceptibility to colds, and, worse, pneu-monia and influenza, ailments that were tantamount to a death sentence at the time; twenty million people worldwide had died of influenza in 1918.

"This time," he said later of the second breakdown, "I discovered through an alert physician that I had been suffering from pulmonary tuberculosis, which has been with me ever since."

The doctor was a Shuster cousin. When he found out the terrible truth of the ailment, he sighed deeply and tried his best to temper his verdict with as much lightness as he could muster. He told Shus that he could stay in Philadelphia and live maybe one year; or, he could move to a high dry climate in the West, where he had a good chance of dying of snake bite, old age, or bad whiskey.

Shus opted for the West.

When Will and Helen left Philadelphia, they did so under the dark cloud of impending doom. Friends and family members saw them off with tears that suggested a final farewell. On his side only Shuster's father remained, his mother having passed away in 1918 while he was away at war. Her absence added to the sadness of the affair, which was more of a wake than a leave-taking.

They rode out on the train on February 29, 1920, and arrived in New Mexico three days later. Bound initially for the well-known art colony of Taos, where people were said to recuperate from TB, neither he nor Helen knew what to expect in the Southwest. Shuster had heard descriptions of the climate and the cultures while still back east, had read the scant reliable literature and consulted the maps, but nothing could prepare him for the exotic beauty of Santa Fe.

Here was a tiny adobe settlement banked up against the snow-capped majesty of the Sangre de Cristo range. Only about eight thousand people inhabited this town of narrow, crooked streets and softly contoured adobe walls. Burros loaded down with firewood ambled down the dusty roads that stretched away from the plaza. In the air drifted the sharp, sweet scent of piñon smoke.

Typical town scenes seemed other-worldly: blanket-clad Indians from the pueblos outside town alighted from horse-drawn wagons and laid out their silver and turquoise wares under the portal of the Palace of the Governors on the north side of the plaza. Proud farmers of Spanish descent hitched their horses and strode across the public square to do business at the hardware store. Women left the nearby cathedral pulling their rebozos over their heads and walked home to pots of boiling red chilies and chewy *posole*. Businessmen from the East, relative newcomers, stationed themselves behind counters in dark little shops that sold dry goods.

Santa Fe was a city of neighborhoods radiating out from the central plaza—barrios, the Spanish called them. Pockets of homes and families lying east and west developed from centuries-old Spanish land use practices, economic necessity, and cultural habits. And each of these was further divided into smaller neighborhoods, many inhabited solely by one extended family. Spanish was the first language of the town.

For the newly arrived, it was a foreign country. It was a rare and blessed place that kept pace with the slow-moving sun rather than the clock. Santa Fe, with its thin, clear mountain air, fiery sunsets, gentle snowscapes, and vast empty reaches, was heaven.

Suddenly, for the first time in many months, the ailing Shuster felt positive about the future. And there was another reason to be hopeful: Helen was pregnant.

The Shusters found lodging at a boarding house on the corner of San Francisco and Jefferson Streets, and there, over the next few weeks, they met a string of artists, writers, town characters, and refugees from the East like themselves.

West San Francisco Street in Santa Fe, 1920, looking east toward St. Francis Cathedral. Photo Archives, Museum of New Mexico.

One of them was the painter John Sloan, who spent only part of every year in Santa Fe. Over the poker table at the boarding house Sloan and Shuster began a warm friendship that was to last more than thirty years.

Sloan was a fine painter of the famous Ashcan School and highly regarded in New York, where he lived when he was not in Santa Fe. Shuster found in Sloan a true model for high ideals, a man who unflinchingly sought personal expression. For Sloan, art was all-important and everything else in life had to be subordinated to it—financial security, social acceptability, and the like. But the rewards were enormous. The freedom to create was, of course, the first reward.

Santa Fe and its people, especially Sloan, represented the dawn of a new life. Will decided that he would become more serious about painting, too, and shortly discovered that his native talent was still alive. Technically he was never Sloan's student, but he was a keen observer and learned from Sloan and other artists how he might approach his own art.

In Philadelphia Shuster had explored painting, studying with J. William Server before the War. Server encouraged him to pursue that elusive aesthetic expression, "feeling."

For Shus, painting always was a way to look carefully at the world, and then give back to it creatively. What he had experienced as a young man was now something he could apply to artistic expression. His best canvases were the scenes of daily life around him that he had observed with a clear eye.

Santa Fe whetted Shuster's curiosity for all of northern New Mexico. He and Helen set out, often in the company of some of their new friends, to see Taos, the cliff dwellings at Puyé, the Hispanic villages tucked away in the mountains, and the ancient villages of the Pueblos along the Rio Grande. In May, just the two of them went to Bandelier in the Jemez Mountains and camped.

While in that wild and lovely place, Helen began to feel the stirrings of childbirth. On May 23, 1920, Mrs. Boyd, who was married to the Bandelier lodge's owner, acted as midwife and delivered prematurely William Howard Shuster III. Six days later the baby died.

They buried him there at Bandelier, amid the natural splendors of the land and the ruins of the long-abandoned Anasazi dwellings, and marked a large rock with the infant's name.

❀ ❀ ❀

The bohemian life of Santa Fe was in full swing in the early 1920s. The town had all the ingredients to appeal to freedom-loving artists. First, it was isolated from the East Coast—as isolated and remote as one could get and still remain in the United States—and from the West Coat as well, though less in the way of established culture can be said to have been going on there at the time. Here an artist could be an expatriate without leaving the country. Freed from the increasing standardization of American life and the conservatism of its art, the artist could explore art in new ways, away from the unavoidable influences and interferences of the big cities and established customs.

Then, Santa Fe was a beautiful place in which to exercise that magnificent feeling of freedom that everyone talked about. The climate was conducive to creation and the mix of the cultures was stimulating.

Finally, the town was a flourishing artists' colony. An increasing number of painters, musicians, and writers was gravitating to Santa Fe; many, like Shuster, for health reasons. It was easy and pleasant to be a bohemian in such circumstances, to nourish eccentricities, and, in general, to enjoy life on one's own terms.

Characters abounded. Shuster was working in a small adobe house on the grounds across Palace Avenue from where the Museum of New Mexico now stands, paying five dollars a month and pinching every penny. One afternoon while he was painting in the back room, a voice roared from outside.

"Is anybody home in there?"

"Yes," Shus shouted back, "Come in."

He then heard the loud clomping of horse's hooves. When he entered the front room he found standing there a man high atop his mount.

"Hello!"

"Who the hell—"

"I'm Mike Clancy. Have a drink." The bewhiskered visitor, a local poet,

raconteur, and rascal, reached into his saddlebag and pulled out a bottle of whiskey. Shuster laughed, sat down with Clancy, and proceeded to get drunk. Then he remembered he had a dinner date with the Sloans. He left the cowboy in the living room and ran over to their house, stealing flowers from backyard gardens along the way to present to his hostess, Dolly Sloan.

In time Shus would be regarded as a kind of character himself in the community. He took on some artistic flourishes that included a 10-gallon Stetson and a flamboyant black silk bow tie of his own design and making. If the occasion happened to be a formal one, the painting smock and paint-smeared dungarees were discarded in favor of a tuxedo or dress suit and the black silk bow tie was replaced with a fresh one.

He was something of a selective rebel. He had no patience for snobbery as it manifested itself in the arts, the sciences, or certain social customs. He avoided confronting people who exhibited this trait, preferring instead to poke fun at the "stuffed shirts," as he called them, of the era by mentioning their affectations in newspaper columns.

Every day was a new adventure. The exuberant Shus, with typical self-sufficiency, addressed practical obstacles with solutions that were every bit as creative as his flowering artistic endeavors. His customized "mobile home" was one such example. Shus occasionally took off on sketching trips that required his being far away from home for more than few hours and sometimes more than a day. He needed a place to live while on the road, and motels didn't exist at the time. (Even if they had, spending money for a night's lodging would have been, to Will Shuster, frivolous and out of character.) His son Don Shuster recalls that "he hit on the notion of cutting off the rear end of a Model T touring car, replacing it with a wagon bed which was wide enough to accommodate a full-sized mattress and a place for a child to sleep. This was covered with wagon bows and canvas—'covered wagon style'—and provided him a means to go wherever he wanted, and be instantly ready for camping. He took with him a fresh water supply, a gasoline lantern for lights, and a Coleman stove for cooking."

Santa Feans called it the "covered wagon" and, in addition to its utilitarian function as a home away from home for sketching trips, it became a Shuster trademark, delighting the community when it appeared in parades with a mock horse attached to the hood that "pulled " it through the narrow streets of Santa Fe. The covered wagon was a fixture in town until 1928, having served Shus— and vicariously, the community—for six years. By 1928 the family finances permitted the purchase of a spanking new two-door Model A Ford.

Helen, meanwhile, reveled in it all. She loved Shus and was delighted with how the West seemed to be magnifying the expansiveness that had always been part of his personality. An attractive, slightly built woman who wore her dark hair in the fashionable styles of the times, Helen was a lively conversationalist

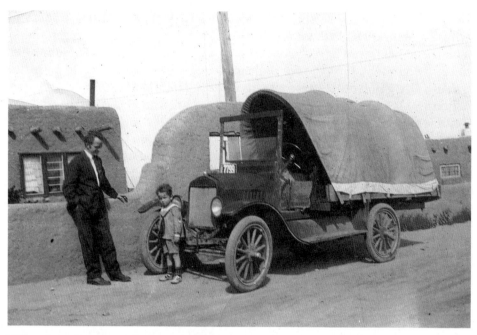

Will and son, Don Byron Shuster, at age two, with the Model T "covered wagon" in front of their first house at 580 Camino del Monte Sol, 1923.

and an avid reader. She spoke with authority, observation, and keen intelligence on a variety of subjects, including literature, politics, and art. In Santa Fe, her own circle widened to include artists and the wives, husbands, and lovers of artists, who joined in the innumerable impromptu parties that were an integral part of the scene in Santa Fe.

In 1921 Helen was again pregnant, and on July 17 she delivered Don Byron Shuster.

That was a busy year for Shuster. He had progressed through pencil and charcoal sketches into painting and back into drawing, had caught charming scenes from life and stunning portraits in oil. By the end of the summer he had accumulated dozens of good canvases to show. In the fall he and four other painters—Fremont Ellis, Walter Mruk, Jozef Bakos, and Willard Nash—were talking about banding together to have their pictures seen. Working on a model that Sloan and Robert Henri had come up with in New York some years before to get themselves and other "dissident" independent painters exhibited in the East (the Eight), they ultimately presented themselves to the public as Los Cinco Pintores, The Five Painters.

The Santa Fe of the Cincos was made up of a number of social classes. At the top were the "old timers," Anglos whose families had come to the city over the Santa Fe Trail half a century earlier; and the "ricos," the wealthy descendants of the Spanish who had been there much longer than that, whose roots extended

back to the time of De Vargas and the *reconquista* in the seventeenth century.

Then there were the working-class people and farmers of Spanish descent; and the merchants, Anglo traders, and businessmen who had come out from the East with the railroad. Finally there were the temporary residents and the tourists, a group of well-heeled old-money types who annually made the trek from New York, Philadelphia, Chicago, and St. Louis to Pasadena, Monterey, and Carmel, lingering at watering holes along the way. Santa Fe was one of the favorite stops on their journeys back and forth across the country.

Some in this latter group were health seekers. Tuberculosis patients from the East and Midwest were routinely sent to Santa Fe, where they found fresh mountain air, a restful climate and, most important, St. Vincent Sanatorium, run by the industrious Sisters of Charity. The sanatorium, which later became part of the city's hospital, had been ministering to TB patients since the 1870s. By 1920, when the Shusters arrived, it was advertising itself in a brochure as "An Ideal Spot for Health-Seekers—The Most Delightful Nook in the Rocky Mountains."

Outside of town, but close enough to Santa Fe to be considered residents, were the ranchers, both Anglo cowboys and Spanish land grant stewards, and, of course, the Rio Grande Pueblo Indians, who regularly came in to trade their crafts.

The artists, whose ranks included painters, novelists, poets, playwrights, musicians, and others, were the catalysts for all these groups. For the monied tourists, the artists were the official court jesters—and their antics, usually in the form of elaborate and memorable parties, brought many of the tourists and townspeople together.

Will Shuster was at the center of all this riotous activity. The venues varied, but La Fonda Hotel and the Bishop's Lodge were the usual places for parties, although many unforgettable social events were held, with little or no advance planning, at the homes of the artists; sometimes parties began at one home and ended the next day at another. The drinking was heroic—and *de rigueur* during Prohibition.

Parties were the stages on which the personal dramas of the Santa Fe crowd were acted out. They were wild affairs, long and festive, and by the time they were over the guests had said things and done things that would be gossiped about until the next party—which was not far off, in any case. Later in life Shuster was able to recall particular parties from twenty and thirty years before and what had transpired at them.

The revitalization and elaboration of the annual September Fiesta was in many ways an outgrowth of the fun the artists had brought to their parties.

Fiesta had been celebrated in Santa Fe since 1712, by proclamation of the then-governor of the province José Chacon Medina Salazar y Villaseñor, the marques of Peñuela. It was the oldest civic celebration of its kind in the country.

But in the late 1920s, consistent with the tenor of the times, Fiesta became quite a bit bigger, lasted longer, and was a lot more fun. Originally a religious commemoration only, the annual observance of Santa Fe's peaceful reconquest from the Pueblo Indians in 1692 was extended to include more elements—a citywide parade, called the Historical-Hysterical Parade, and the children's pet and costume parade—El Desfile de los Niños.

The most boisterous of the Fiesta additions was the 1926 creation of Zozobra, a giant paper puppet whose immolation marked the start of the festivities. Shuster designed the enormous puppet and oversaw its construction for nearly four decades. When Zozobra went up in flames, it symbolically incinerated all the cares and woes of the previous twelve months, making way for the new year of joy, happiness, and fun.

A description of the first Zozobra burning appears in the September 2, 1926, edition of the Santa Fe *New Mexican:*

Following vespers at the Cathedral, a long procession headed by the Conquistadores Band marched to the vacant space back of the city hall, where Zozobra, a hideous effigy figure 20 feet high, produced by the magic wand of Will Shuster, stood in ghastly silence illuminated by weird green fires. While the band played a funeral march, a group of Kiwanians in black robes and hoods stole around the figure, with four others seated before the green fires. When City Attorney Jack Kennedy on behalf of the absent Mayor, solemnly uttered the death sentence of Zozobra, with Isidoro Armijo as interpreter, and fired several revolver shots at the monster, the green fires changed to red, the surrounding ring of bonfires was ignited, red fires blazed at the foot of the figure and shortly a match was applied to its base and leaped into a column of many colored flames. As it burned the encircling fires blazed brighter, there was a staccato of exploding fireworks from the figure and round about, and throwing off their black robes the spectators emerged in gala costume, joining an invading army of bright-hued harlequins with torches in a dance around the fires as the band struck up "La Cucaracha." Following which the crowd marched back between bonfires lining the streets to the armory and the big baile was on. It brought out the biggest crowd of native merrymakers seen here for years. . . .

The dancers were led that night by local poet Witter Bynner, whose place was later taken and elevated to an elaborate fire dance by the famous dancer and Santa Fe resident Jacques Cartier. The well-known photographer Wyatt Davis was the moaning, roaring voice of the Gloomy One.

Zozobra, which has gone up in flames every year since Shuster created it in 1926, became one of the symbols of the city, a potent reminder of the madcap celebrations of those times and of one artist's generous dedication to his adopted home. In the 1930s its form progressed from a bald bogeyman to a much fancier apparatus with rolling eyes and a mouth that opened and shut.

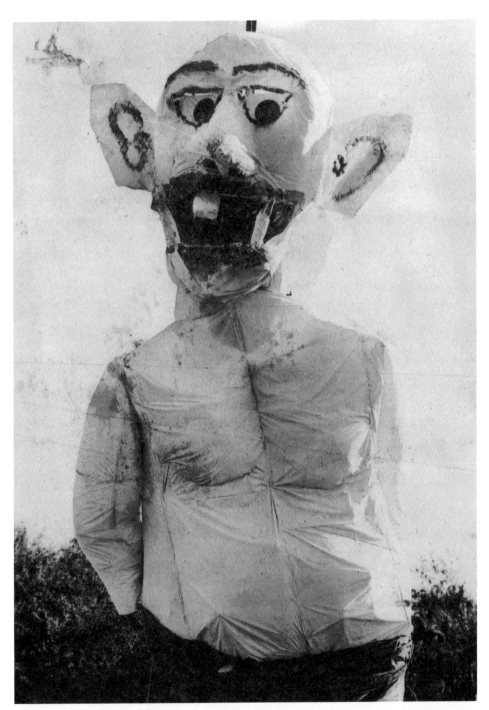

First Zozobra, "Old Man Gloom," designed by Will Shuster and burned behind the Old City Hall on the night of September 1, 1926, to mark the beginning of Fiestas. The head was fashioned of papier mâché by artist Gustave Baumann. Photo courtesy Anita Gonzalez Thomas.

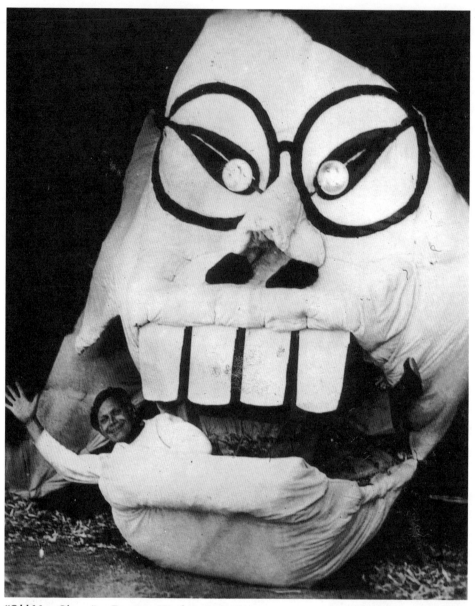

"Old Man Gloom" as Emperor Hirohito, in 1943.

During World War II it variously took on the appearance of Hitler, Mussolini, and Hirohito. At one point, when wartime shortages made it difficult to find the appropriate materials, Zozobra shrank in size; a miniature version of the puppet made a brief appearance in the 1946 film *Ride The Pink Horse* based on the novel by Santa Fe writer Dorothy B. Hughes. More recently, Zozobra has appeared in the Dennis Hopper film *Backtrack*.

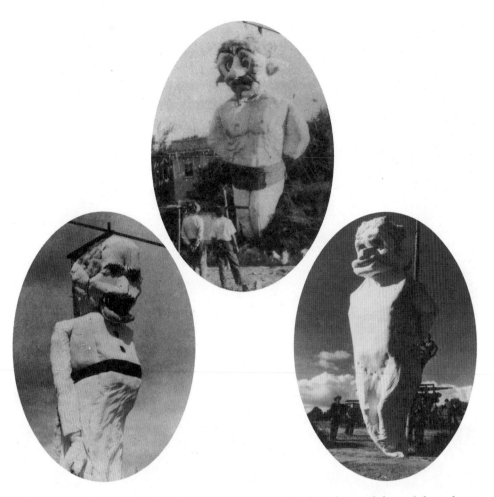

The changing faces of Zozobra: The late twenties (top), the late thirties (left), and the early forties. Photos courtesy The Laboratory of Anthropology and The Great Southwest Books, Santa Fe. In 1964 Will Shuster assigned all rights in and to Zozobra to the Santa Fe Downtown Kiwanis Club, which retains exclusive copyright to the figure.

The years ahead would bring to its creator more bohemian abandon, more creative accomplishment, and more recognition. They would also bring pain, both physical and emotional, divorce, and financial troubles. Through it all Shuster would grow personally, with the new responsibilities of fatherhood, and as an artist. A great deal had transpired since that dark day when he and Helen had embarked from Philadelphia with hopes for something fresh and fine out West. In the high desert Shuster's new life had begun to bloom.

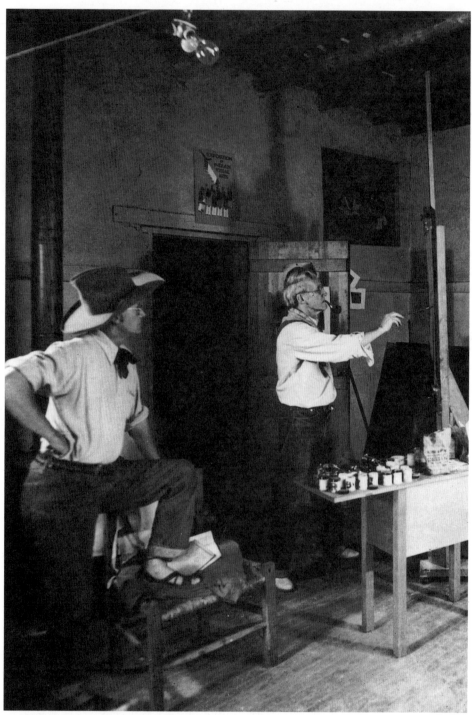

Artist John Sloan at his studio easel at 314 Garcia Street, with Shus looking on. Photo by Ernest Knee. Courtesy of Eric Knee.

2

Shuster and Sloan

First of all I am healthy, supremely happy and have shaken off mental fetters and extraneous things that have been holding me back. I feel for the first time like a painter—a real whole-hearted dyed in the wool painter with no ifs, ands, buts, perhaps and maybes fastened on my life. I feel that I have crawled out from one phase of life into another. Let's hope it is good. But good or bad, it can't be indifferent. I'm on the loose and something is happening.

—Shuster to Sloan
The Letters, December 19, 1926

John Sloan first came to Santa Fe from New York in 1919. By that time he was a prolific, but not yet fully recognized, painter. Indeed, at the beginning of that fateful summer when he and Dolly accompanied the artist Randall Davey and his wife on the tortuous auto trip west, Sloan had sold only a very few paintings.

He had been earning his living as an illustrator of books and magazines. What small reputation he enjoyed in the East was localized around a circle of friends and fellow painters that included Robert Henri, Ernest Lawson, William Glackens, George Luks, Everett Shinn, and others.

Much of that reputation rested on his approach to painting and what he chose to paint, as well as on his obvious talent. Sloan went against mainstream

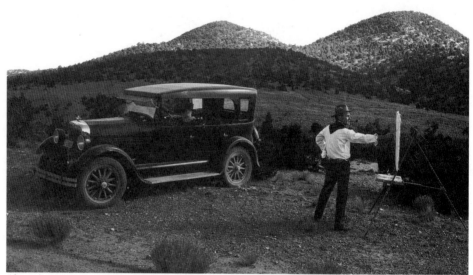

Sloan painting near Monte Sol the summer of 1926 with his wife, Dolly, in the car. Photo by T. Harmon Parkhurst. Photo Archives, Museum of New Mexico.

thinking of the period by taking his subjects from life and concentrating on the ordinary, as opposed to the idealized. His canvases depicted the working-class masses, armies of real people who inhabited the throbbing metropolis of Manhattan.

That first summer Sloan and Dolly stayed briefly at the boarding house run by "Mom" and Jack Akers, about two blocks off the plaza; they subsequently bought a place on Garcia Street near the river, just off Canyon Road.

Well known in her own right as a humanitarian and early feminist, Dolly Sloan (née Anna M. Wall) was her husband's "favorite subject matter" for portraits, and she frequently commented that Sloan was her "career." During their extended periods in New Mexico, Dolly Sloan was one of the organizers of the "hysterical" parade, which became an annual Santa Fe Fiesta event.

When Will and Helen Shuster arrived in town in March of 1920, they also boarded with the Akerses. Shus, observing the robust health of the free spirited Santa Fe artists, determined that he would have the same for himself. That summer the twenty-six-year-old Shuster got together over poker with the elder, patrician John Sloan, twenty-two years his senior, and the two began a close friendship that was to last until Sloan's death three decades later.

Their relationship was firmly rooted in a love of art and the artist's way of life. Both had the strong sense that one's life and one's art were inseparable, and the further conviction that the artist lived outside the conventions of generally accepted social norms. Throughout their artistic careers, neither ever seriously entertained the notion of working a nine-to-five day for someone else, even

when their financial resources had dwindled to nearly nothing.

Other than art, Shuster and Sloan had only their eastern backgrounds in common when they met—Sloan hailed from the small central Pennsylvania town of Lock Haven—but by the end of that first summer the two men had forged the foundation of a lasting and richly supportive friendship.

They were together only four or five months out of the year, when Sloan was in Santa Fe. During the winter and spring months they corresponded in lengthy letters between New York and New Mexico. Fortunately, the letters were kept at both ends, and taken together they form a fully drawn portrait of the two artists and of the deep friendship they sustained over thirty years.

Some of the letters are filled with news and enthusiastic updates on each of their careers; others are moody and reflective. Sloan writes complaining about the sorry state of his bank account; Shuster replies with encouragement, pointing to Sloan's increasing successes with his painting career. Shuster writes of his continual battle with the authorities to be compensated for his war injuries; Sloan answers with sage advice, pressing him to return to the easel as a way of soothing his spirit.

Sloan invariably sketched quick cartoons at the end of his letters, from time to time extending them along the margins and onto other pages. After Don Shuster was born, Sloan never failed to mention him in the letters with a drawing all his own, usually showing Don flying an airplane or performing other feats of derring-do. Sloan appears as himself in the cartoons, smoking the pipe that he was rarely without, greeting the boy with a big "Hello, Donnie!"

Many of the letters are a record of their respective illnesses, particularly as the two men aged. Sloan was not particularly strong of constitution; as the years crept upon him he spent more and more time in the sickbed. At one point, in the 1940s, he came so close to death that Shuster confessed afterward in a letter that he had nearly given up hope for Sloan's recovery.

Shuster also found himself down with a complaint occasionally, usually an ailment related to the lung damage he had suffered during the war. Colds and worse, influenza, which was not taken lightly at that time, kept Shus in bed once or twice in the winter months. Typically, he used the time well, writing letters when he was up to it, or musing on life for future correspondence with his friends. Some of his best, most searching and thoughtful letters to Sloan were written after he had recovered from an illness.

The women appear in the letters only briefly. Sloan always addressed his correspondence to the "Shuses" and Shus began his letters with "Dear John and Dolly," but it was clear that the observations traded back and forth were the men speaking to one another.

Helen herself uncharacteristically wrote a series of letters to John and Dolly after her divorce from Shuster in 1935. She had begun a recovery from her own serious health problems and seemed to be writing mainly to assure them that

she would shortly be in a position to pay them back for a modest loan that saw her through a difficult time. The letters inject a melancholy note into the written conversations between Shuster and Sloan, neither of whom mentions Helen after the divorce except when they occasionally allude to her health.

The most powerful passages in the letters are when both men abandon the items of news, daily aggravations, and the other surface details of life to plumb deep and bring up soul-searching observations. Shuster was more inclined to do this than Sloan, though Shus wrote from the heart infrequently and only when prompted by an unusual impulse.

Most of the time Shus looked up to Sloan as an older brother who had molded a life in art with his bare hands, as it were, and had been successful at it, an attitude that might have encouraged the younger man to compose correspondence of a confessional nature. At least three times in his letters Shus shared with Sloan a penetrating clarity about the direction his life was taking; in those instances Sloan, who was less comfortable with such outpourings, acknowledged the intensity of Shus' remarks with affectionate pats on the back, but did not respond in kind.

Sloan kept his gentler emotions in tight rein on paper, and for the most part Shus did the same. They were gentlemen painters of the previous century in that way: the convention of letter writing itself, especially with the unflagging fidelity that Shuster and Sloan applied, harks back to an earlier time when the charm of distance provided an opportunity for the epistolary art.

"Dear Sloan," Shus perkily begins a letter to his new friend on November 30, 1920, after Sloan had returned to New York from their first Santa Fe summer together. "Yesterday I had the first real painting day in a week, and sure gave 'em hell."

He was in better control of his colors and more thoroughly in command of his subjects, ready to communicate the joy of his new-found life. He encloses photographs of his recent work in the letter and speaks about finishing a portrait of a woman, adding that he thinks it is "pretty damn good." Then on a more serious note he tells Sloan, "Here's the dope. In so far as I'm going to be (or am) an artist, I'm trying damn hard to be a real one. Now, if I ever do amount to anything, a more or less complete photographic record of my painting will be worthwhile. There will be two records. One with John Sloan— t'other with Shuster."

The concern that his life somehow be documented crops up frequently in Shuster's personal writings. Later, in his diaries, he often scolds himself for not adhering to a more strict schedule of day-to-day record-keeping.

However Sloan might have reacted to being the young man's mentor (and photo archivist), it is clear that the two made a profound first impression on each other during that summer. At the outset, and forever afterward, Shus looked up to Sloan as a pupil to a master, though they were never formally that.

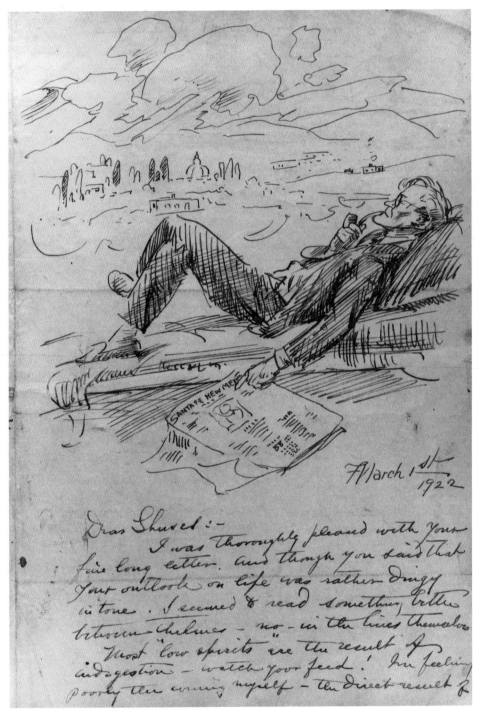

Typical illustrated letter from Sloan to Shus; this from New York in March 1922 in pen and ink showing Sloan day dreaming of Santa Fe.

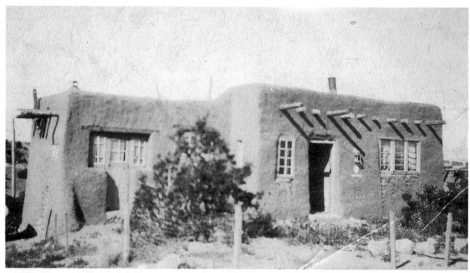

580 Camino del Monte Sol in the mid-1920s. The house built by Shus, photographed in 1923.

A frantically busy Sloan writes to Shuster in 1922 asking him about the progress he is making on the camino house. "I hope that your home is about finished by this time so that you will be able to lay off building and paint. *Somebody* ought to paint. I'm not getting the chance, and here in N.Y.C. it's hopeless almost—there is so damn much else to attend to."

But in the midst of a storm of activities, Sloan takes the time to invite Shuster to enter a 1921 Independent Exhibition in New York. "I wish you could," he says encouragingly, "and if you will send a couple [of paintings] I'll pay your entrance fee, $10." He spends the remainder of the letter giving a two-page, step-by-step description of how to size and frame a painting properly.

The Independents show was a personal crusade of Sloan's. He felt he had to buck the system that found his working-class subjects unacceptable. As early as 1908 he and his friends had shown their work apart from the National Academy of Design; the "outlaw salon" was housed in the Macbeth Galleries, and the painters were referred to as the Eight, surely the inspiration for the Cincos of Shuster later in Santa Fe.

A month after his request, Sloan, still waiting for Shuster's entry, finally receives a letter from Santa Fe announcing that the adobe house Shus had been building is finally finished enough to move in, and that Shuster has also been involved in an amateur theatrical presentation.

"*Be faithful to your calling* if you possibly can," Sloan shoots back. "A good picture stands a good picture for ages. A good actor's work is like a good meal—digested and gone." Two weeks later he again chides, "Don't try to be good at everything, just be an artist—merge them all to that focus."

Shuster at last sends off a painting to Sloan in New York that he had just

completed. While nothing is today known of the work, Sloan's exasperated response to it is worth quoting in its entirety:

> Today Budworth [the head of the selection committee] returned your "Saban-dura" or whatever you call it. It had been passed beneath the noses of the thirty wisest art guys of the National Academy and rejected—which is just what I expected, altho' I had not seen it until its return. I was so damned busy on the Independent installation and hanging last week when it arrived on the 8th that I couldn't even open the box. I just cursed your foolishness and phoned Budworth to take it to the place of execution in one of their carts.
>
> It is not at all the sort of picture to get by *any jury*. It's not *bad* enough, nor is it good enough.
>
> Never, as a general rule, send off a painting which you have *just finished*. You are still in that necessarily hypnotic state which produced it and should wait for the state of *exacting* criticism, which will come later on. . . .

There would be other exhibitions, other rejections, and other opportunities for Sloan to help bring Shuster into the world of painting. Through it all Shus would find in John Sloan a helpful critic of his work, a firm supporter of it, and, in all ways, a loyal friend who cared about the younger man's advancement.

Shuster may not have had a serious problem with alcohol, but he went through periods when liquor was the handiest way to smooth the rough edges of life on the camino. Though he rarely mentioned this to Sloan in his letters, he was almost always in need of more cash. His relationship with Helen became stressful in the mid-1930s, before their divorce, and the domestic situation with Sami, his future wife, was rocky and on edge for long periods, beginning shortly after they were married. Add to these strains the chronic problems associated with the war injury, which put Shus in bed several times each year, and the ordinary frustrations of an artist trying to pursue a creative life, and it is not difficult to see how alcohol could have become an important staple in the Shuster cupboard.

"Sober enough to see the keys and to think with some degree of clarity," he begins a letter to Sloan in 1924. He had just returned from a party in Tesuque and was "a bit illuminated—so much so that Helen would not let me drive the car back to Santa Fe, in spite of my vigorous assurances."

Later he says, "I have been feeling rotten—too much alcohol, I presume— and I am preparing to spend several days in bed recuperating."

What Shus and his friends had been drinking during that particular time was homemade liquor. Prohibition had forced ordinarily law-abiding citizens to create their own supply of alcohol, either by buying it from a bootlegger or making it themselves. Shuster and some of the others in the artist crowd tried their hand at various types of drink, from brandy to gin, with more or less success.

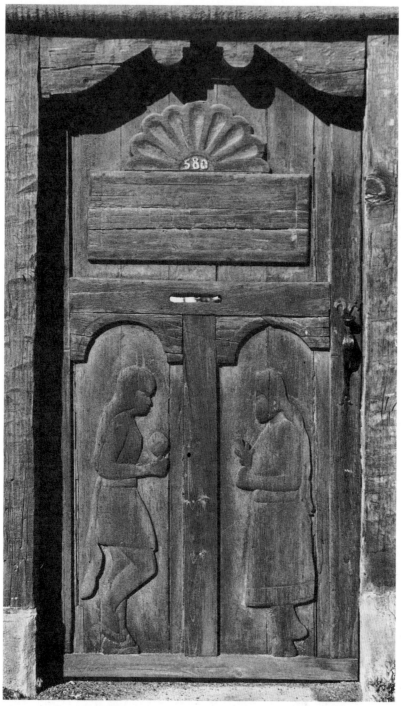

Shus' hand-carved wooden door at the gate of the 580 Camino del Monte Sol house. Photo by Nancy Warren, 1988.

At last, and inevitably, the ample stores of alcohol at Shuster's were in danger of being discovered by the law. Two weeks before Christmas 1924, he spent one harrowing night removing the evidence that might have sent him to prison.

This is what he wrote to Sloan:

"Shus, you're wanted on the phone." "Hello" Ashby Davis very seriously, "Shus, that tin thing that you have around the house . . ." "Yes . . ." "Get it off the premises right away." "Thanks"—Jesus! right at supper time. What a sweat. Tops of the cans, two of them, under the bed, a crock full of mash that was to be run that night over the floor. Knock-knock-knock at the front door. Christ! "Well I'll be damned"—Andrew Dasburg. "What's the trouble? Did a pipe burst?" Then the story. What to do with the cans. Hurriedly out into the night with them, across the arroyo; into the pinon trees. Back again with a strong odor of alcohol leaking out of the cesspool. Calm. But we couldn't eat the rest of our supper. Couldn't get Gus (Baumann). Waiting, tried again. After many unsuccessful attempts finally got him and told him to come over—right away. Reticence—persuasion, finally all right and over he came. Then the story accompanied by a gradual dropping of the jaw. Out into the night to find his can. Searched eight million pinon trees, finally finding the culprit. Gus goes home. Pours out twenty gallons of a wonderful mash. Works until two in the morning in old clothes crawling through the mysterious byways and passages of his house secreting fifteen gallons of various flavors from the eyes of Uncle Samuel. Bang! Against a pipe goes a gallon jug of creme de menthe. Shovel and a box, shoveling up the odor. Then turpentine as a neutralizer. Then for the first time in months he realized the odor which permeated the household. Sulphur candles, disinfectant. Now we are all pure and holy.

The federal agent did not materialize that night, but he had been heard bragging in town that he knew of three stills in the artists' colony and was going to get Will Shuster.

Sloan surely sympathized with Shuster's panic and must have felt equally as devastated by the thought of all that liquor being destroyed. Sloan was a drinker, and the diminutive Dolly, who by many around her was considered an alcoholic, could match him drink for drink.

At the end of one summer holiday the Shusters gave the Sloans a bottle to take with them on the train. John and Dolly finished it long before they reached Chicago and then drifted into what Sloan describes as "a very long sleep" of thirty-two hours. He later commented that it was the most pleasant passing of the journey between Santa Fe and New York that they had ever experienced.

Through the 1930s there are fewer references to Olympian drinking bouts and monumental hangovers, but Shuster reported to Sloan on some of the memorable parties of the Santa Fe artist crowd. Sometimes the parties were planned, sometimes impromptu. Often they began gradually when someone saw someone else's car parked outside the Shuster house, and ended two or three days later at another house and, from time to time, in another town.

"Helen surprised me with a birthday party and everybody seemed to have a merry time," Shus writes to Sloan a year after the incident with the bootleg liquor, "but that last party at [Witter] Bynner's still echoes and re-echoes in my mind as a real top notcher, and my sides still hurt to think of it."

It was *la vie bohème*, encouraged by the congenial climate and exotic culture of remote New Mexico. Despite occasional frustrations, for Shuster at home and Sloan on summer reprieves, Santa Fe could be very sweet.

❀ ❀ ❀

Painting. Work.

Long passages in the letters between Shuster and Sloan are given up to the misery and joy of painting pictures. For both men, art formed the core of their lives. When one of them falters and slips into self-pity or self-torture over a failed episode with the muse, the other is quick to send a word of encouragement.

"Oh boy, what a dismal frame of mind you were in when you wrote the letter I received today," Sloan writes cheerily to Shuster in 1925. "You are quite evidently not at all well—I shant bother with your specious reasoning against painting pictures—a waste of time to write such bosh, unless, as you admit, it lets off steam."

Shus had been painting on the final versions of the Carlsbad Cavern series and had reached a creative impasse.

"Perhaps it's time for me to tell you that I never could really understand your interest in the bowels of the earth," writes Sloan. "I did like the pictures and I saw how you enjoyed painting them . . . but if any advice is worth anything, you can hear it: come back to human life—life of the Indian people—the world about you—simpler motives—you have proved that you can paint them—let's have more of them *if you please.* Anyhow, you *have* also proved you can paint caves. Make some other attack."

Only Sloan could have spoken to Shuster in that tone of voice, at once paternally accepting and gently exasperated. For Shuster, the older painter's approval was something to be sought at every important juncture in his artistic career, but he just as often discarded Sloan's advice, independently and intuitively going his own way. Still, Shus continues to write often to Sloan on what turn his work is taking, hoping for positive feedback from New York. But Sloan is sparing with his praise.

"I am busy now trying to get into the Christmas etching game," writes Shuster with a glibness that belies the extent of his new interest in print making. It was Sloan who had been initially responsible for Shus' getting started in etching when he sent him a textbook on the principles of etching. "Painting has been at a standstill because of the etching splurge," he continues, "but somehow or other it doesn't bother me much, for I feel that I am getting somewhere anyhow.

Two of Shus'whimsical greeting cards from the mid-1940s, featuring Shuster family and pets. Courtesy The Great Southwest Books, Santa Fe.

These little etchings I think are as good if not better technically than any which I have done to date. I am sending you a bunch of samples for criticism."

"I bet you've had your abdomen full of printing those wee little bargains for Xmas cards," Sloan fires back. "Harder to paint than 5 × 7 plates, I think. Printers hate them. I don't think the scheme could possibly pan out any profit—too cheap—no appreciation—and *no pay for your work*."

Despite Sloan's objections, Shuster was able to make money on the Christmas card etchings and continued to produce them for many years afterward. They were deft, charming scenes of everyday life in Santa Fe—a graceful adobe wall frosted with snow, a twisted piñon tree in the desert, Pueblo deer dancers. Often he put himself and the family in the pictures: the Christmas card for 1946 showed Shus, Sami, the two children—Linda and John Adam—and the family dog riding into the heavens on a rocket ship while angels sang on a puffy cloud. In his letters to Sloan, though, Shus is careful not to mention the etchings as more than a hobby and a way of tending to the household bills.

Shus spent a great deal of energy that might have gone into his art simply trying to stay one step ahead of the bill collectors. When he was able to have a sustained period of creative time to himself, he was happiest. The day after

Christmas 1926, his etchings aside, he wrote to Sloan with obvious emotion:

> Life begins with the steps to the studio and ends each night up the steps out.
> John, you have no idea of the difference it makes in my life. No matter what my
> actual position is I feel bigger, more free, happier and healthier than I have felt in
> all my life here in Santa Fe. I feel as if I am constantly on the eve of some great
> thing and I hope better things are happening. At least when you return next sum-
> mer I want to show you a winter's work that will make you feel good in the reali-
> zation of the fact that whatever pain, anxiety or discomfort your move to help
> me has caused you, that it has been worthwhile and that I have more than
> responded, and we are all wealthier in spirit because of it. Damn it all if this
> hombre can't paint it's just because it's not there, not that I am not trying. I feel
> that it is and as I said before, I feel bigger and better in every way, and if anything
> great is going to happen, it's going to begin this winter.

Realizing that he is confiding his innermost thoughts to Sloan, and perhaps
sensing a vulnerability in baring his secrets, Shuster adds, "I feel like a sentimen-
tal ass as I write this stuff, but really, John, there is an insatiable something gur-
gling down in my depths and for the first time in my painting experience I feel as
I said that something is about to happen."

The premonition did not deliver any astonishing flowering that time, but
Shus had brought his most profound feelings about his creative life to his friend.

In New York, Sloan embraces Shuster's candor with a fatherly hair tousling,
admitting in his own way that convention has prevented them from com-
municating at that deep level. The letter "was a thriller," Sloan says. "I liked it
and *can't feel* it is 'rot' or sentimental junk. It seems quite a real outpouring. I'm
glad you mailed it to me, for I realize that it is a kind of frank expression of feel-
ing that one sometimes hesitates to make—I feel flattered that you made me the
receptacle."

Sloan responded to Shuster's openness and affection in less overt ways also. A
poignant passage in one of Sloan's letters from New York speaks about his fas-
cination with the infant medium of radio and uses the listening experience as a
point of contact with his friend, thousands of miles away.

"The radio goes on amusing us," Sloan writes, "and tonight I thought, as I
have often before, listening to some of the Columbia and National Broadcasts,
that perhaps you and Helen were listening to the same sounds."

Shus' own long interest in radio never waned and he kept his knowledge of
the medium current with the times. He built a fine, powerful receiver that could
pick up stations all over the country. It boasted a strong speaker. The radio
became the focus of years of social evenings as friends (including the Sloans)
and neighbors gathered at the Shuster home to listen to "Amos 'n Andy" or to
hear an opera or a nationally broadcast sporting event.

With the onset of the depression, the fortunes of both Shuster and Sloan took

a dip. In December 1932 Sloan complains that a recent sale of one of his paintings is a mixed blessing: he has sold it, and that is good, but he has had to settle on a price that is substantially lower than he would have gotten five years before.

Shuster is worried that the government will cut his veteran's benefit: "I have been granted a pension of forty-five dollars a month until 1936 that is then reduced to twenty-seven dollars a month until 1940, and then it quits. I suppose by that time I am supposed to have starved to death or to have become so despondent that I would bump myself off."

But just when Shuster's finances appeared their most desperate, he was awarded work through the Federal Art Project, a program administered under the New Deal's WPA. He writes to Sloan that he had proposed three different projects: the first, to paint a series of portraits "of the distinguished Indian artists of this region" in uniform size; the second, "to redesign the currency and stamps of the United States using Indian design elements in the incidental design;" and the third, to execute a series of large paintings of the Carlsbad Caverns. The first two proposals were rejected, but the third was enthusiastically accepted.

Beginning in 1935 dramatic changes came over the Shuster household. Will and Helen were divorced, and within a year Helen developed a cancerous condition that ended with the amputation of her right leg. Shus moved out and into another place, settling in quarters nearby; Helen remained in the first house.

During her convalescence Helen lived briefly at El Zaguan, then a residential complex on Canyon Road. From there she wrote the Sloans about her slow healing process, adding that she was working hard to pay them back for money they had loaned her; whether it was money for the operation or simply to tide her over a difficult time, is not clear.

"We have had a lot of snow and I will be glad when it is over with, as it is impossible for me on crutches," she writes at the end of January 1939. "Almost had a serious fall . . . wrenched myself severely and was in agony for ten hours after." She closes, asking for a letter from John and Dolly; between the lines she seems to be asking them not to forget her. Maintaining the friendships she made while with Shuster was evidently important to her.

Shus, for his part, was married again, to Selma Schaumann in the summer of 1937. Sloan's letters from then on are addressed to "Shus and Sami," and there is every indication that the Sloans became as friendly with Sami as they had been with Helen.

On their journey west in 1939, the Sloans carried with them precious cargo, Sami's seven-year-old daughter Linda. On the train trip across country, Sloan entertained Linda with stories, though he more often retreated to the club car. Left to babysit, Dolly was ill-at-ease with the child. Clearly she would have preferred to join her husband for a drink. During the stop-over in Chicago the Sloans lost Linda in Marshall Fields department store. Back on board, Linda

bumped her head on the upper berth and wore a bandage when she was finally delivered at Lamy station outside of Santa Fe.

The summer of 1940 was a lovely one for the Shusters and the Sloans in Santa Fe, full of hard work at the easel and unforgettable good times at parties. But that winter Sloan, back in New York, became very ill and had to undergo an operation.

"Damn! I hope everything goes well with him, and you too," Shuster writes to Dolly from Dallas, where he and Sami had gone to deliver paintings for a regional art exhibition in which Shus was participating. Five days later, from Santa Fe, a worried Shuster says to Dolly, "My heart is sick about it all. I really feel downright sick about it, but somehow or other I have a strong feeling that John will pull through all right. . . . The world just can't afford to lose my John Sloan."

Sloan did pull through, but only barely, and when he was recovered enough to write to Shuster he first complained of the outrageous hospital bill ($2,500), which Dolly was able to settle by selling some of his paintings and etchings, and then admits that "I'm still a long way from 'being myself,' not so sure I ever will be, but *quien sabe?*"

Truthfully, Sloan was never quite himself after that. He was well enough to spend the next seven summers in Santa Fe, however, in the company of the Shusters and the ever-widening circle of friends in the colony.

One other bout of illness struck Sloan, this while he was summering in Santa Fe in 1942. "Sloan very sick," Shus wrote in his diary for July 10. "Something must be done to help Sloan arrange his affairs." A week later the hospitalized painter's condition was so grave that Shus recorded that he had "worked with Sloan and Francis Wilson [a local lawyer] on Sloan's will."

Again, amazingly, Sloan bounced back. Some days later Shus smuggled liquor into the hospital and had a long, cheerful visit with his much-improved friend. On August 10, a month after he had been admitted, Sloan left the hospital: "a miraculous recovery," Shus noted in his diary.

During the war years, Shus, ever the inventor, conceived an idea for a bomb that would throw out "cluster bomblets." He wrote a long letter to the War Department that included drawings and technical details. The letter suggested that the idea be pursued. Shus received a "thanks-but-no-thanks" response from the government, which ended the correspondence. It is interesting to note, however, that the idea was later utilized. So-called "cluster bombs" are now much-produced conventional weapons.

Shus became involved in many civic activities, one of which was serving on the gas rationing board during World War II. Again he saw his fortunes dwindling. He writes, disheartened, to Sloan, "Our own finances are going from bad to worse, and I am going to have to find a way to make some *dinero*. It has been so goddam long since I sold anything that this whole art set up with me has

become one hulluva dragging expense with absolutely no income. I will probably have to try and find some kind of a job for myself to keep the ball rolling."

❀ ❀ ❀

"Dolly Sloan died Tuesday, May 4 and was buried on Thursday, May 6, 1943," Shuster noted without comment in his diary. After a few months John Sloan married Helen Farr, nicknamed "Pete." Thirty-six years her husband's junior, she had twice been his student, once in 1927 and again in 1934. She later assisted Sloan in editing his autobiographical critique, "Gist of Art," and had served as director and secretary for the Society of Independent Artists.

Through the latter years of the 1940s Sloan continued to visit Santa Fe and was very much a part of the artistic and social life of the town. But his frequent illnesses were turning him into a shadow of his former self.

It was Pete who decided that Sloan was too weak (and perhaps too old—he would be eighty in August) to endure another trip west and in the spring of 1951 broke it gently to Shuster that on the advice of Sloan's doctor they were going to "take a change this summer and try the White Mountains [of New Hampshire] instead of the Sangre de Cristos."

Shus answered, "Naturally I was a bit shocked to hear that you were not coming out this summer. It is hard to believe that the routine of years will be changed. However, the Docs should know best, and I am sure no matter where you go you will have a good time. Sloan carries that quality with him."

It was a polite response, but behind it was enormous hurt, and Shus confided to friends that staying in the East for the summer might have been more Pete's idea than the doctors'. He resented being denied the older man's presence, for he was certain now that he would never see Sloan again.

At the end of summer came the inevitable note from Pete: "Good affectionate letter arrived yesterday morning—in harsh contrast I must tell you that today the incontrovertible evidence of biopsy taken yesterday—Sloan has cancer of the lower bowel."

The artist was operated on immediately, and the operation was a success, but his recovery was fraught with complications. Sloan died peacefully in a coma on September 8.

One summer day in 1924 Will Shuster and John Sloan painted portraits of each other in a "duel" at John's house. Many years later Shus described the work of that afternoon in an article for the Santa Fe *New Mexican*.

> The orchard in back of the property that Sloan bought [at 314 Garcia Street] was filled with fruit trees of many varieties. So expertly grafted were they, that several kinds of fruit grew on many of the trees.
>
> There in the midst of that orchard, John built his studio. On top of it, at

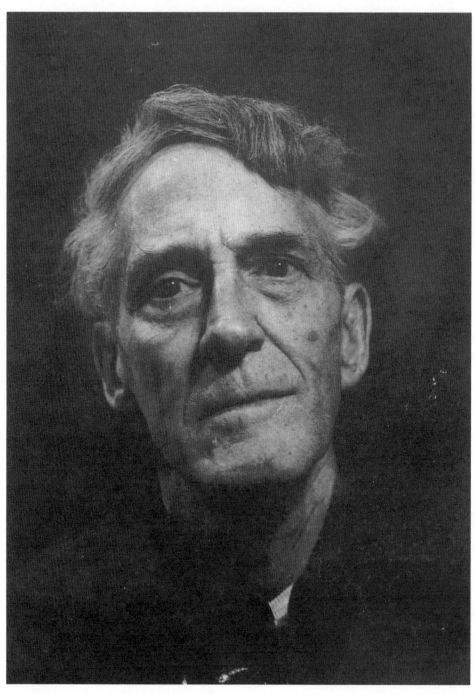

John Sloan in 1950, a year before his death.

Robert Henri's suggestion, he built a tower with a railed platform, about eight feet square. From that tower above the trees one could survey the whole countryside. Henri's idea was that an artist did not really need to own a large place as he possessed all he could survey

Sloan was a perennial child. Although there was 22 years' difference in our ages, we worked and played together like a couple of kids.

Year after year on his arrival in Santa Fe, Sloan would putter about the place doing everything but paint, and get increasingly crotchety because he was not painting. Year after year, Dolly would privately say to me, "Shus, this has gone far enough, take Sloan out sketching. Get him to work. Life with him this way is hell." And so, we would a sketching go. As John became immersed in his work his crotchetiness slipped from him and he became the happy searching child.

It was a morning of one of those early years, when we were both idling in the orchard, each perched on a limb up in the Seckel pear tree eating our fill of those hard but deliciously sweet morsels, that Sloan said to me, "Shus, let's paint a duel this afternoon."

"A duel?"

"Yes, I'll paint you and you paint me at the same time."

And so it happened. We worked like beavers, but with a strange feeling of doing double duty . . . trying to be kind to the other fellow, and pose a bit, and at the same time concentrate on the all-important job of painting.

That afternoon gave the two artists, kindred spirits, the opportunity of seeing each other through the mirror of the painted canvas. What resulted were pictures of two intense men looking closely at each other, trying to see everything in the other. It was an inspired celebration of their friendship, and the promise of an affectionate bond that would endure for the next quarter-century.

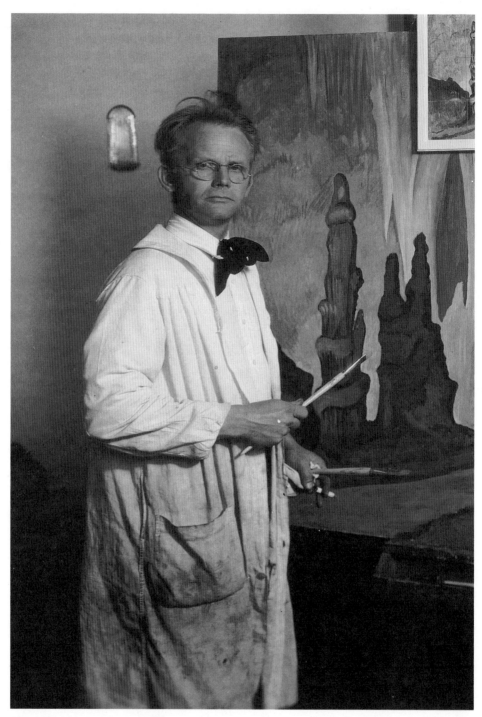

Shus at his camino studio with his second group of Carlsbad Cavern paintings executed in the 1930s.

3

Los Cinco Pintores

*We did not form to become a social club, artist equity or any-
thing like that. It was a banding together for survival.*

—Interview, Santa Fe *New Mexican*
January 30, 1966

f interest to Santa Fe's artistic community was a headline that appeared
in the October 29, 1921, issue of the Santa Fe *New Mexican*:

BEGINNING OF GREATER ART
COLONY ON CAMINO MONTE SOL

Interesting Group of Studio Homes on
Picturesque Thoroughfare; Young
Painters Flocking to Spot to
Build Dwellings

The opening paragraph of Ina Sizer Cassidy's article that followed was
provocative: "If to have an art colony it is necessary for the artists to live in a cer-
tain community, then Santa Fe, which has thought it had one before, is truly
now to have one, which may be the beginning of a great colony. Who can tell?"

To the north, the Taos Society of Artists was firmly entrenched. Joseph
Sharp, Ernest Blumenschein, Bert Phillips, E. Irving Couse, Herbert Dunton,
and Oscar Berninghaus formally founded the society in 1915. Several of them
had met in Paris. Disenchanted with the sameness of the artistic subject matter

they had found and rejected in Europe, they gravitated to the West and specifically to Taos. Here their work was inspired by the simplicity of the lives of the Taos Indians and the early Hispanic settlers—their religious rituals, architecture, and daily working lives.

Santa Fe, too, was established as an art colony, albeit a more informal one. In addition to John Sloan, artist William Penhallow Henderson had not only established residency with his poet wife, Alice Corbin, but also had built a house on the camino, along with ceramicist Frank Applegate. Randall Davey, Gustave Baumann, Carlos Vierra, Sheldon Parsons, Gerald Cassidy, and B. J. O. Nordfeldt were all full-time Santa Fe residents.

Some of the artists who settled in Santa Fe had come for reasons of health, while others, intending merely to "stop over" on their way to somewhere else, became enchanted with the place and stayed. In addition to the pure mountain air and dazzling light, artists were inspired by the Museum of New Mexico's plans for a fine arts museum, completed in 1917, which would secure for Santa Fe its place as an art center for the entire Southwest.

The interest generated in the art community after 1920 was in large measure due to the fact that five young painters were actually "colonizing"—preparing to build their studio homes in close physical proximity to one another, thereby to be identified together personally and professionally.

Fremont Ellis, Walter Mruk, Jozef Bakos, Will Shuster, and Willard Nash arrived in Santa Fe within a year of one another. They had youth in common (all were under thirty years of age when they came to Santa Fe), and none of the five had studied art in Europe, although study abroad among young Americans was common practice at the time. Exactly how and where they all met once they were in Santa Fe is uncertain, but some interesting conjecture presents itself.

"Mom" and Jack Akers' boarding house at Jefferson and San Francisco streets might well have been a meeting place, as it certainly had been for Shuster and Sloan. The warmth provided by the wood stove in the combination living room and kitchen was apt to be inviting not only to ward off a seasonal chill for those who gathered around it, but also because Jack, a gregarious host, poured a generous drink of bootleg whiskey for residents or those who just dropped in. He also encouraged poker games several nights a week and hurried "Mom" through the task of tidying up after her simple, well-prepared evening meals so that the serious business of getting a poker game underway at the kitchen table could be speedily dispatched. His guests surely included, from time to time, the artists already established in Santa Fe, as well as the newcomers. Informality was the way of life in the small art colony of the 1920s, and to drop in at the boarding house or an artist's studio for a visit or just to get acquainted was not uncommon. It was, in fact, encouraged.

There were studios behind the Museum of Fine Arts which visiting artists,

such as Sloan, were allowed to use, and on Palace Avenue, on the site of the present First National Bank parking lot, there were two adobe houses which the owners rented to artists for a nominal fee as studio space. Shuster rented one of these spaces, and he and Sloan often visited back and forth between their studios located across the street from each other. It is probable that the other young, newly arrived artists behaved similarly, coming and going between their respective studios, having professional conversations about their work, or simply enjoying casual chit-chat over a morning cup of coffee.

However their initial acquaintance may have come to pass, their individual reasons for coming to Santa Fe in the first place differed somewhat, but not radically.

Fremont Ellis was the first of the five young painters to arrive in Santa Fe, in June 1919. A native of Montana, he had subsequently lived in New York and later, as an adult, in Texas. He had had a short period of formal training in art at the Art Students' League in New York, but was largely self-taught. He longed to paint southwestern landscapes and was encouraged by his father to do so. He had exhibited in El Paso, and when he visited Santa Fe, his intent, like that of so many artists before and after, was to stay for a summer visit. But captivated by the city, he stayed on and made it his lifelong home.

Walter Mruk and Jozef Bakos, the only two of the five artists who had known each other prior to their arrival in Santa Fe, were both natives of Buffalo, New York, and both sons of Polish immigrants. They had studied at the Albright Art School in Buffalo and had been students of John Thompson in that city. When Thompson relocated to Denver, Bakos joined him there in 1918; Mruk soon followed. While still in Buffalo the young men had seen traveling exhibitions of paintings of western subjects, and were fascinated by the genre. Once they were established in Denver, both set about painting and exhibiting scenes and landscapes featuring the dramatic Rocky Mountain area. Subsequently, in 1919, Bakos accepted a position as an art instructor at the University of Colorado and moved to Boulder; Mruk stayed on in Denver.

But in the early months of 1920, tired of the bitterly cold Colorado winds, Mruk made his way to Santa Fe. Less than a month later he invited Bakos to join him, which invitation Bakos accepted, as the university had been closed temporarily due to a flu epidemic. The men were beguiled by northern New Mexico and in particular Santa Fe. When the university reopened in Boulder, Bakos finished out the academic year, after which he and Mruk returned to northern New Mexico, where they took jobs as forest rangers at Rito de los Frijoles, now known as Bandelier National Monument. Each painted area landscapes during their time in the rugged Frijoles Canyon and shared an exhibit in Santa Fe. Bakos moved to Santa Fe permanently in early 1921, and Mruk followed soon after.

Will Shuster, of course, came to the West because to do so was to avoid a pre-

mature death. With a future uncertain at best and Shus' health of grave concern to all, it was a grieving group of family and friends who treated the departure as a wake and bade Shus and Helen a mournful goodbye as the train left the station in Philadelphia bound for the outer limits of civilization and sanity. There must have been at least a measure of relief in the Shuster and Hasenfus households in Philadelphia when word came that Shus and Helen, having arrived in Santa Fe on March 3, 1920, decided to stay there instead of continuing on to the smaller, less accessible Taos to the north. Although Shus didn't know what he would do or how he would make a living when he left Philadelphia, his introduction to Sloan almost immediately after his arrival in Santa Fe sealed his artistic fate.

Willard Nash spent his first summer in Santa Fe amassing information and material for a mural he had been commissioned to paint in Detroit. With that project completed in 1921, Nash returned to Santa Fe, where he remained for some fifteen years. Like Shuster, Nash was a Philadelphian, though he had grown up in Detroit and studied art there. Also like Shuster, he suffered from a lung ailment, which had brought him to the West—Montana—in the first place. During his early years in Santa Fe, Nash was rumored to have an art patron in Detroit, someone from whom he received periodic monetary allowances. The steak bones that appeared with some regularity for the neighborhood dogs after a meal at the Nash household lent some credence to the rumor.

The decision of the five young artists to band together was explained by Shus in an interview in 1966, as he reminisced about the "old days" in Santa Fe:

> We did not form to become a social club, artist equity society, or anything like that. It was a banding together for survival. There were times when one of us wouldn't sell a painting for a year or so, but maybe one of the others was lucky. We shared each other's luck. In those days you could buy a side of beef for a few dollars and a gallon of whiskey for about $4, so we all ate and drank.

While sharing each other's luck assured them of physical survival and certainly gave them collective moral support, their artistic survival was a bit more complicated.

They were the new kids on the block, not yet firmly or individually established on the local or national art scenes. The innovative "open door policy" of the new Museum of Fine Arts, championed by Robert Henri, wherein any artist could submit works to be exhibited, was of some support to their early efforts to gain recognition. But as they were unknown, "they'd stick our work in little out-of-the-way corners somewhere," Shus said in the 1966 interview. Moreover, some private difficulty between Edgar L. Hewett, the museum's director, and Shuster resulted in additional insult when the latter's work was hung "next to the men's room." As there were no commercial galleries in Santa Fe at the

time, the artists' capacity to expose and sell their work was extremely limited.

An equally serious manifestation of the exhibiting problem was that, as unknown painters, their works were not accepted for large, juried shows in major cities. The juries in Chicago, Philadelphia, and New York, the cities where the art academies flourished, were comprised almost solely of a group of people deemed to be expert in given art genres. The well-known, ultraconservative eastern artists were looked upon favorably by the equally ultraconservative jury members. When these artists submitted works to be considered for a given show, usually by invitation only, almost certainly their paintings were accepted by the jury, reinforcing an exclusive "old boy" network. "Only by such favor could an American artist expect to succeed," states Arrell Morgan Gibson in *The Santa Fe and Taos Colonies, Age of the Muses, 1900–1942.* "Most young aspiring painters were excluded, with the result that there was no place of note for them to show their work."

Shuster, because of his association with Sloan, had had works exhibited at the Kraushaar Gallery in New York, and Bakos and Mruk had exhibited with Thompson in Denver, but these were exceptions. The young "modernists" sought recognition on their own merit, but they were considered too radical even for the tastes of the old guard to the north—the Taos Society of Artists. They found themselves painting with fervor but floundering with frustration in their inability to exhibit widely and attain the recognition each worked hard for and deserved.

When he talked about "The Santa Fe I Really Knew" to a packed auditorium in the Museum of New Mexico's Fine Arts Building in late January of 1966, Shuster recalled a late after-dinner conversation he had had with Bakos—"Jo" to his friends—that took place in the studio that Helen and Shus rented from Sloan at 314 Garcia Street. It was 1921. He remarked urgently to Bakos, "Jo, we've got to do something about this."

Bakos shared his concern regarding their inability to exhibit as they wished to. The two of them quickly rounded up Mruk, Nash, and Ellis for an unplanned but lengthy and comprehensive conference about their shared dilemma. They decided that a united front of young modernist painters could be a force to be reckoned with in the eyes of national museum jurors and gallery owners, whereas individually they could accomplish little. On the local scene, they felt that banding together would solve the problem of their work being hung, if at all, in obscure or otherwise unflattering spots in the museum.

And what exactly was a young modernist in 1921? From the collective point of view of the five who aligned themselves in order to survive artistically, it was that the painter painted what he saw and did not adhere to any one school of art. The modernist sought to let the painting—not a school of painting—speak for itself. The modernist ignored formula and illustration, thus assuring him no commission from such august establishments as the Santa Fe Railroad for

realistic calendar scenes. The modernist eschewed melodramatic representations of area subject matter, electing the use of forceful line to define rugged mountains instead of the hazy outlines preferred by the Barbizon school, for instance. The modernist dared to experiment with bold color to achieve the realism of plains, mountains, a Navajo blanket, even the color of human skin.

Bound by no common style or technique, the young painters instead brought a variety of singular styles to their canvases. They were firm in their resolve that they would not be categorized or labeled as belonging to a particular artistic movement. Perhaps in their youthful fervor to get their artistic lives going in a remote art colony in the West or as a result of their geographical remoteness from the metropolitan art centers of the country, they didn't recognize that their combined philosophy was, if not a movement in the Southwest, at the very least a bold and daring stand for the time and, in particular, the place.

Comments from their contemporaries often appeared in print. Alfred Morang, a Santa Fe painter and art critic, said of Will Shuster's work:

> In the contemporary art scene two types of painters occupy the spotlight: experimenters that search endlessly for new forms and painters that follow more or less a single line of development. Will Shuster is an artist who has followed one line of development; . . . [his] color concept is broad. Largely confined to earth pigments, his color covers a wide range, from rich greens to yellows of astonishing intensity.
>
> He feels that when method becomes obvious in a picture, then the creative impulse ceases to exist. Shuster is . . . an artist sensitive to the basic values of human life, a painter in close contact with the emotion of the scene depicted, and a man sympathetic to the beliefs and ideals of his fellow man.

With great elation, the five eager young painters realized that they had organized themselves. And now that they were organized, what to call their unique group? Ellis suggested "The Five Painters." He had recently married a pretty Spanish girl from the area and her participation in the discussion persuaded them that in a culture where the Spanish language had been spoken for centuries it would be appropriate for them to be identified by a title that linked them to the Spanish heritage and culture of the area.

"The Five Painters"? No. "Los Cinco Pintores"! Thereafter they were known, thanks in large measure to Laurencita Gonzales de Ellis. A proud and pleased Santa Fe came to call them simply "the Cincos."

Initially bound by the necessity for personal and artistic survival, the Cincos quickly made their mark in the community in a variety of other ways. It was the time of the Roaring Twenties. The five were young, fun-loving, and a bit wild. They were gregarious and social. The wealthy summer tourists who stayed at Bishop's Lodge, the La Fonda Hotel, and the area dude ranches, as well as those who had summer homes and private estates in Santa Fe, soon realized that the

Los Cinco Pintores: From top left, Jozef Bakos, Fremont Ellis, Will Shuster, Walter Mruk, and Willard Nash, taken in Santa Fe in the early twenties. Photo Archives, Museum of New Mexico, and The Great Southwest Books.

Cincos could be counted on to enliven a party or to start one. It wasn't long until the Cincos, and other established artists in the community, became the "in" people to include as party guests. They were invited to the social gatherings of the more reserved "establishment," too. The bohemian element in town had come into its own—socially and artistically—with panache and flair.

Several of the artists contributed different talents to a well-made soiree: Bakos played the violin and performed Polish dances with great zest, and Mruk drew amusing cartoons. Shus played the accordion well and frequently accompanied himself as he sang "Ach du Lieber Augustine." He also was often the featured entertainer of the evening. A superb raconteur, actor, and mime, he developed and collected a repertoire of narratives which required consummate storytelling and acting skills.

Shus' personal theatrical style was one-of-a-kind. He combined presentational theater, in which the performer confronts the audience directly, deliberately eliciting its response, with a vaudevillian touch, sometimes using bawdy gestures and much eyeball rolling and eyebrow wiggling. Often he delivered his monologues in a foreign accent, several of which he had mastered.

He honed his talents in the early 1920s, to the delight of summer residents, fellow artists, and old-time Santa Feans, at large parties and small gatherings. Over the years his repertoire grew and included disparate and entertaining titles that included "How to Twist a Tiger's Tail," "The Man Who Found a Hair in his Soup," "Chinese Testimony at a Trial," and a ribald, complex production about the Ellises' fierce French bulldog and how it was cured (in the performance) of its propensity for pugnacity.

During a typical evening of Shuster hospitality, guests gathered around the living room fireplace after a fine and filling meal of kidney stew prepared often by the host. Everyone settled down with something to drink, and typically, someone spoke up with a request for Shus to perform.

"Hey, Shusie, do the 'Tiger's Tail.'"

"Nope," the host declined. He pulled his wire-rim glasses down on the end of his nose, cocked his head, and winked at his guests. "I've got a new one. Back in a minute." And he left the room momentarily.

Delighted, everyone pulled chairs back to provide a space for the favorite entertainer to perform his latest mime-cum-monologue.

The host reappears dressed in a tuxedo jacket with a white handkerchief folded into the breast pocket. "Zis iss about Olaf, smartest member uff animal kingdom," he announces in a Swedish accent, and without further preamble, Shus moves to the space provided him and takes center stage.

He carries with him an ordinary kitchen chair, which he sets down. With exaggerated gestures of great dignity, he pulls the chair from an imaginary table and not quite correctly flips his tails behind him as he seats himself. He "shoots"

Shus on accordion and photographer Wyatt Davis, partying at the second Shuster home at 550 Camino del Monte Sol in the 1940s.

his cuffs and in so doing nearly knocks over an imaginary glass, which he carefully rights. Scratching his head, he glances furtively to the right and left and mimes the fingering of the various items of cutlery and glassware on the table. His uncertainty as to the use of some of the items of cutlery reveals that he is uncomfortable at a formal dinner party. Peering over his eyeglasss and glancing about, he registers this fact with a nervous licking of his lips. He places his hands in his lap and begins to twiddle his thumbs. Then he quickly sits on his hands. He looks to his right.

"Vy, senk you. Unt gut efening to you as vell."

Peers to his left. "Medem. Gut efening. I yam Svedish. From Sveden." He extends his hand. It is ignored, left hanging in midair, then drops.

He sits on it again, clears his throat, moves his hands to his lap again and once more twiddles his thumbs. He tries again.

"Medem. I vonder if you vould like a glass uff vater?" Reaches for an imaginary pitcher. "Vat? Oh, yes. Ze vaiter vill do it. Yes, yes." Puts his hands back in his lap. Shoots his cuffs again. Clears his throat, adjusts his floppy bow tie, looks to his left again.

"Medem. Ven dinner iss ofer, vill you dance wiz me?" Pause. "No, medem? Zank you wery much, medem."

Summer costume party at The Bishop's Lodge in 1928. Dolly Sloan, center, in striped dress; John Sloan seated next to her with Indian necklace and mustache; Willard Nash, Carlos Vierra, Jane and Gus Baumann, Witter Bynner, Wm. Penhallow and Alice Corbin Henderson, and Shus and Helen, among other revelers.

A look of determination crosses his face. Spits first on one palm, then the other. Slicks back his hair. Tries again.

"Medem. Vat do you zink of ze vorld situation?" Pause. "Vat? You don't zink of ze vorld situation? Zank you wery much, medem."

He leans away from her, glancing at her out of the corner of his eye. He tilts his nose up in the air with his forefinger and purses his lips prissily, indicating that she is "snooty." He lifts an imaginary teacup to his lips, pinkie finger extended to mimic his impression of her. He replaces the teacup and dismisses her with a wave of his hand. He turns to his right as though to speak with the person there, pauses mid-action, and an expression of pure devilry crosses his face. He wiggles his eyebrows, shoots his cuffs again, and assumes a mock-serious expression. He clears his throat and turns once again to his left.

"Medem. I vonder, vould you be a luffer uff animals?" Pause. Then, delighted, "Oh, medem, zen zis iss your lucky day. Vis pleasure, I show you Olaf. Smartest member of animal kingdom."

With great care he extracts the folded handkerchief from his breast pocket and even more carefully unfolds it, one tri-corner at a time, until it is draped over his hand.

"Medem. Meet Olaf. Vorld's most talented flea. Oh, careful, medem. Not too close. Zis fellow, he iss shy, a little bit. In yust a minute, Olaf vill perform a trick. Now vatch carefully."

He inclines his head close to the open handkerchief. "You ready wiz ze trick,

Olaf? Medem is vatching you. You must be wery gut. Now! Yump, Olaf, Yump!"

He rolls his eyes from left to right. "Medem! Vas zis not a vonderful trick?" Pause. "Vat, medem?! You saw nozing? Medem, you must vatch wery carefully. Olaf do it again for you. He vill yump even higher zis time." Inclines his head to Olaf. "Vunce more, Olaf. Ready? Gut boy."

Pause. "NOW! YUMP, OLAF, YUMP!" He shouts the command.

"Gut boy, Olaf! Zere vill be special treat for you later. Medem, vasn't zat vonderful? I am like ze proud papa. VAT, medem?? Again, you saw nozing? But Olaf do his trick yust for you. Vait. Let me zink."

He thinks for a moment, then bends his head low over the handkerchief, whispers, then raises his head.

"Medem. Olaf wishes to please you. He vill attempt most difficult trick." He picks up an imaginary knife, holds it in his other hand. "Medem. Olaf vill yump to the blade of the knife and back again. He must be wery, wery careful, or else . . . vell, vun slip, no Olaf. I vould be wery, wery sad.

"Now, Olaf. You ready? NOW! YUMP, OLAF, YUMP!

Silence. He carefully replaces the knife on the table and slowly reaches toward the woman's bosom and plucks a minuscule object from it between his thumb and forefinger.

"Yours, medem? Zis not Olaf."

Whether the Cincos hosted parties or attended them, they frequently created themes, urging guests to attend in costume. One such gathering was a "Reincarnation Party—Come As What You'd Like to Be in the Next World." Among the guests at this gathering, hosted at the Bakos home, was a Jesuit poet who had been "exiled" to Santa Fe for failing to write a complimentary poem about one Cardinal Gibbons. He had, instead, written an amusing but unflattering jingle about the good cardinal, which alluded to the cardinal's attire of red ribbons and his earnest wish to be pope. The poet appeared at the Reincarnation Party dressed as the pope, an indiscretion for which he was reportedly held accountable to the Church. People who had attended the party urged him not to worry about it (if he did at all), since he was already exiled!

The annual artists' and writers' ball, launched in the 1930s and held every year at the La Fonda Hotel, was an outgrowth of the Cincos' love of hosting and attending costume parties. Shus was frequently the chairman of the affair, overseeing his committee's efforts to create an annual "glitterata" with a different theme each year. The gala held in 1933, "The Blue Sea Baille," a grand success, was typical of their flair. The Santa Fe *New Mexican* reported:

Costumes ranged from sea weed to huge turtles and light houses, old salts, pirates, penguins, bathing beauties of the gay nineties, fish of every conceivable

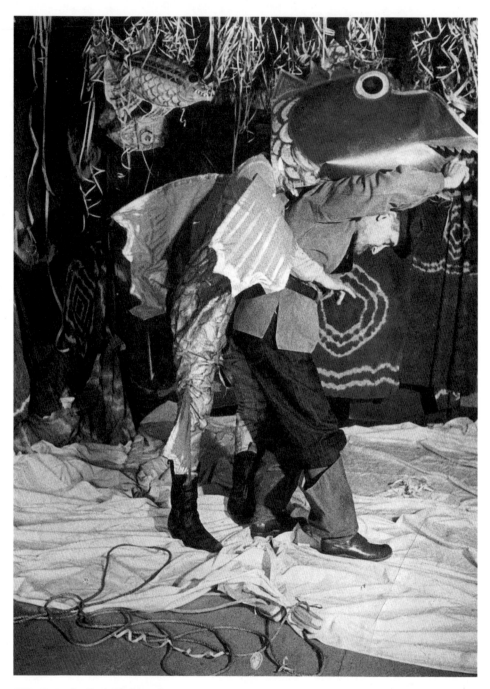

"The Deep Sea Baile" held at the La Fonda Hotel in the 1920s. The large fish is Will Shuster being dragged in by artist Carlos Vierra, garbed as a Portuguese fisherman.

species, mermaids and mermen, everything even most remotely connected with the sea. Such startling originality, beauty and grotesqueries were never before seen on a Santa Fe dance floor.

The costume parties during the heyday of the Cincos were the forerunners in later years of parties at the Shuster home and always included a wide circle of friends: artists, children of friends, friends of the Shuster children, somebody's houseguests or in-laws, drop ins, the neighbors, and even strangers. The parties celebrated a birthday, the completion of a painting, a national holiday, a sunny day or anniversary—and there were parties to celebrate nothing more than the fact that there hadn't been a party in awhile. An enormous box in the Shuster home contained the trappings of costuming creativity: gowns, tights, tiaras, capes, coats, sashes, swags of fabric, feathers, scarves, boas, beads, skirts, shirts, pants, shoes, hats, petticoats, peignoirs, ties, jewelry, gewgaws, junk—a treasure trove from which guests were invited to create a costume to enhance the celebration of the moment, whatever it was. And they did for well over three decades.

It was also in the Cincos' heyday that bootlegged liquor could be obtained, but at a price. So they made their own moonshine. Shus' specialty was a raisin-apricot (and sometimes grapefruit and potato peelings) brandy-like concoction that was always eagerly awaited by the neighbors. As though clairvoyant, they would know when it was time for "the run" and appear at the Shuster doorstep for a sample from the milk bottle that caught the raw, fiery brew as it dripped from the condensation tube of the homemade still. The condenser that disappeared before Christmas of 1924 during the "night of panic" turned up years later in the crawl space under the Shuster home when Shus and his son Don, twelve or thirteen at the time, were burrowing about the nether regions of the house doing some repairs. Shus stared at the thing for a good long while, shook his head, and said, "Well, I'll be damned."

Bakos made beer and wine, Ellis didn't make spirits (he wasn't as much interested in distilling and imbibing as the others were), Mruk just drank (in fact, had severe problems with alcohol and had to be hospitalized from time to time), and Nash was the one among the five who, due to the largesse of his benefactor in Detroit, could afford with some frequency to buy a bottle of "good" bootleg liquor. His consternation must have been acute when the local bootlegger met with an accident, which was noted in an early Shuster diary: "Sam McKircher best boot legger and moonshiner in town cashed in this day although this is a late entry and I didn't find it out until Monday. Smashed into a telegraph pole. Badly cut in temple. Walked to [nearby] house and bled to death. Thus passes our bootlegger."

If the Cincos played hard by night, so did they work hard by day. Their collective decision to band together not only assured their personal survival, it evidently inspired their work and cemented not only their personal and profes-

sional friendships, but also their artistic philosophies as well. The November 1921 issue of *El Palacio*, the periodical of the Museum of New Mexico, stated:

> Though their work differs widely in concept and execution, they are conscious of the common bonds of youth, sincerity and the strength of individualism. They believe that individual expression is the most prolific source of creative art, and have banded together to increase the popular interest in art, to develop individual expression, and to protect the integrity of art by combining their resources. One of the first steps will be to arrange an exhibition to be sent to the larger factories and mills of industrial centers to be there exhibited to the working men and women in the very environment in which they work.

Los Cinco Pintores had their first group exhibit at the Museum of New Mexico in November 1921. They were "properly exhibited" and, whether by chance or design, their group show made an artistic statement: it fairly exploded with color. Their bold and unstinting use of color was applauded by other artists, a viewing public that included both the artistically educated and those who were not, and by critics—the Cincos had come into their own. Although their desire to take art to the working men and women "in the very environment in which they work" was not fulfilled at that time, the philosophy remained and each of them, over the years, gave of his art in a variety of philanthropic and public ways.

The Cincos exhibited in 1923 at the Los Angeles Museum Exposition Park in an "Exhibition of Paintings by Artists of New Mexico." That their work was exhibited at a large metropolitan museum was a happy realization of another dream for them. The show was, in fact, arranged by them and included the work of fifteen area artists.

These early shows defined the five painters together and individually in the artistic community where they had chosen to live and work, and in circles outside their immediate geographical domain. As a group, this is what they had set out to accomplish. Perhaps it was poetic or artistic justice that by 1929 the Museum of New Mexico had designated a special alcove—the Modern Wing—to display the works of artists known as "the modernists."

Given their efforts to become recognized locally and nationally and to earn a living from their art whenever possible, it was particularly gratifying to Shus when he received acclaim for his work as noted in the February 23, 1923, issue of the *New York Times*. At the time, a group of his etchings was being shown at the seventh annual exhibition of the Society of Independent Artists in New York.

> Former Lieutenant John [sic] Shuster of the late war, who has had trouble with his lungs since being gassed in France and is living in New Mexico is showing etchings and has sold several. Young Shuster is considered by many—John

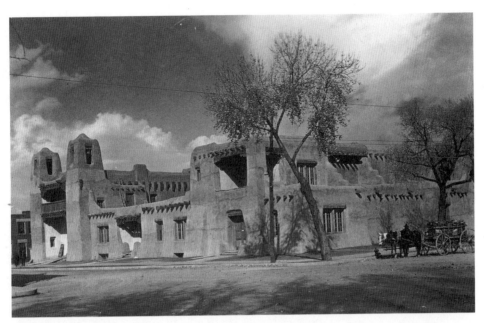

The Museum of New Mexico's Museum of Fine Arts at the corner of Palace and Lincoln avenues in 1920, the year Shus arrived in Santa Fe. A bronze plaque commemorating Shuster's life and work is set in the walk on Lincoln Avenue near the corner. Photo by T. Harmon Parkhurst. Photo Archives, Museum of New Mexico.

Sloan, President of the Independents among them—as the coming artist among those who have recently taken to painting in the Southwest. An interesting feature of the young Shuster's work is that he had not even considered painting before he began to work. A full set of his etchings were sold before the exhibition opened, and many have been sold since. Courtenay Foote, the actor, has been a purchaser since the opening of the show.

One exploit shared by Shus and Mruk combined art and adventure and perhaps plain foolishness, as thought by some, but the end result dazzled artistic communities everywhere and brought well-deserved accolades to the two painters. In 1924, Shus has been reading with mounting interest of the discovery of the Carlsbad bat caves, in southern New Mexico. A man named Jim White was credited with discovering their existence and a photographer from the area, Ray Davis, with a second photographer, Carl Livingston, were the individuals responsible for publicizing the romance and mystery of the deep caverns, accessible in 1924 only by the most primitive means—a mine bucket, lowered by ropes from a pulley.

Shus and Mruk decided that here was an opportunity for a "first." They wanted to be lowered into the caves, now known as the Carlsbad Caverns, and sketch, by the light of gas lanterns, the wonders of the giant stalagmites and stalactites which had been seen at the time by only a handful of hardy adven-

Walter Mruk and Shus preparing to descend into the caverns at Carlsbad during their painting trip there in 1924.

turers. Arrangements were made for them to undertake this venture through Davis, and Mruk and Shus, with a third companion, T. Harmon Parkhurst, a Santa Fe photographer who became a celebrated documentarian, set out on the long trip from Santa Fe to Carlsbad in a Model T touring car.

Mr. Parkhurst was an enormous, red-faced man whose florid complexion seemed to indicate a fondness for spirits—the moonshine or bootleg whiskey of the era. Such was not the case, however. His red face notwithstanding, he was given to over-indulgence in lemon drops and carried with him, especially on long trips when he was photographing southwestern landscapes, a stomach pump to relieve abdominal attacks brought on by a surfeit of the sugary lemon candy. True to form, Mr. Parkhurst began popping lemon drops as the touring car left Santa Fe for the long trip south to Carlsbad. He consumed several large bags of lemon drops long before the trio reached its destination. Somewhere in the vast desolate stretches of flatland that typify the southern part of the state, the photographer became violently ill.

Shus stopped the car, Mr. Parkhurst reached for his stomach pump and lurched out the door. A look of indescribable horror passed over the man's red face.

"Oh, my God, I've forgotten the water for the pump! It won't work without water!" There was no water in sight and in 1924 no rest stops existed. There were few, if any, filling stations between towns.

Shus planted his foot on the fender of the Model T, pushed his ten-gallon hat

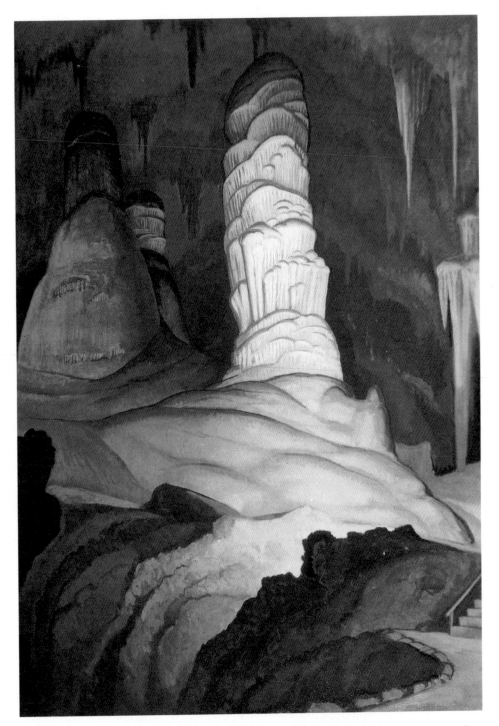

Shus returned to the caverns at Carlsbad in 1934 to complete another series of paintings. This is his "Rock of Ages."

to the back of his sandy head, and took his time about putting together a roll-your-own.

"Well," he said, after he had the cigarette fired up, "I guess we could drain the radiator."

It is lost to history whether Mr. Parkhurst took Shus up on the offer, or if water was procured in the next town, or if the man simply suffered the rest of the way to Carlsbad. It was not, however, the last of Mr. Parkhurst's mishaps on the trip.

Once in Carlsbad and at the cavern site, the men were lowered by mine bucket into the pitch-black interior of the cave. They were equipped with their sketching materials and gas lanterns and very little else.

"When we reached a spot we both liked, we'd set up the two lanterns for light and each of us would go to work making drawings," Shus said in an interview with the Santa Fe *New Mexican* in 1954. They lost track of exactly how much time they spent in the caves. "We'd make that long crawl back up to the first cave and then one of us would have to climb up 170 feet of ladders to man the winch and haul the others up in the bucket. We'd go through all of that and as soon as we reached the top we'd swear then and there that we'd never go back down again."

One of their items of equipment, left at the top, was a gallon of moonshine, brought along for "emergencies." Each time they emerged from the cavern after a day's sketching, they would "have a few drinks and get to talking and swapping yarns and by the next morning we'd be all ready to go back down for another look around."

They were warned to be watchful, especially since their only source of light was their gas lanterns, for various impediments that could cause a fall and possible serious injury. They were also admonished to watch for holes in the floor of the cavern. Mr. Parkhurst didn't listen. He took a serious fall into a six-foot-deep pit and suffered a mild concussion. It was with a great deal of sweat and strain that the overweight, six-foot, three-inch Mr. Parkhurst was hauled from the pit and "evacuated" from the cavern.

Despite the adventures and misadventures, Shus and Mruk brought back a wealth of sketches from their sojourn into the depths of the dark, from which both men created oil paintings. Shus' works were objective in form and highlighted in whites, grays, and blues, while Mruk incorporated elements of fantasy into his paintings. The only time the two sets of paintings were exhibited together was at the Museum of New Mexico in the mid-1920s. Deservedly, the accolades for both painters were superlative. Artists and nonartists alike declared in the *New Mexican* on January 14, 1925, that "they are the most extraordinary pictures shown here in a decade." Shus donated his set of paintings to the National Park Service, while Mruk left New Mexico with his in 1926. In the 1930s, Shuster returned to the Carlsbad Caverns and executed

Shus' controversial nude study of "Jeanya the Dancer" banned in Chicago in 1926.

another set of paintings, these under the auspices of the WPA Federal Art Project. Because they were painted under electric lighting, these later paintings are warmer and utilize more color than the earlier canvases. Shuster again donated the paintings to the National Park Service.

In late 1926 Shuster executed a nude painting entitled *Jeanya the Dancer*. He submitted it for inclusion in an exhibition sponsored by the Chicago No-Jury Society of Artists to be held in a gallery on the second floor of Marshall Field & Company. The picture was hung, along with several other nudes by artists from around the country, but the exhibition time for the paintings was short-lived. Two women representing the Illinois Vigilance Committee saw the exhibition and, shocked by the nude paintings, asked the chief of police of Chicago to do something about them. Two policewomen were sent to the exhibition hall to investigate the situation, and by nightfall the pictures were ordered taken down, despite the protests of the secretary of the No-Jury Society and the person in charge of the Marshall Field galleries, both of whom argued "of new freedom and ancient art." It was a sad business all around, the No-Jury Society agreed, but back in Santa Fe Shus was having the last laugh. As soon as he learned that

This is the Cartoon Which Was Censored By The Mayor of Santa Fe

Who prevented its inclusion in
LAUGHING HORSE NO. 17

Chronic Appendicitis, of course! *By Will Shuster*

Shuster's infamous cartoon for The Laughing Horse Magazine's *"Censorship Issue" of February 1930, which was itself censored. Courtesy of The Great Southwest Books.*

the painting would have to be removed from the exhibition, he wired the society to clothe the figure: "A drape is to be pasted on the painting and on the drape the famous line *'Honi soit qui mal y pense'* which has been freely translated into English as meaning, 'to the pure all things are pure.' "

Three years later Shus experienced censorship once again, this time with an ironic twist. The February 1930 issue of *Laughing Horse*, a Taos-based periodical published by Willard "Spud" Johnson, was devoted to essays and quotes submitted by regional and nationally known authors and artists on the subject of censorship. Shus' submission was, according to Spud Johnson, a "cartoon depicting a haloed censor and an innocent babe named Literature in the operating room of a hospital—a cartoon of the most innocuous and gentle kind, but a very funny one."

In the cartoon, the doctor-censor is about to cut off a daisy as it blooms from Baby Literature's private parts. (The baby's facial features bear a striking resemblance to those of Will Shuster.) The cartoon did not appear in the No. 17 issue of *Laughing Horse*. In its place an editorial apology appeared in which Johnson explained that the cartoon had been "suppressed by a man . . . who disapproved and could think of no way to prevent its inclusion except to keep the drawing in his desk drawer until the edition was about to go to press." Johnson did not reveal the man's name in his insert. However, he concluded his editorial by inviting the public to send for free copies of the cartoon if desired. The copies of the cartoon prepared for public distribution were captioned:

> THIS IS THE CARTOON WHICH WAS CENSORED
> BY THE MAYOR OF SANTA FE
> Who prevented its inclusion in
> LAUGHING HORSE No. 17

Once again, no doubt, Shuster was laughing last. His censored statement on censorship generated publicity and amusement for years to come. His gentle good nature at poking fun at authority was once again evident.

Among the collaborative efforts of the Cincos, none was met with more amazement and amusement by the citizens of Santa Fe (and, in fact, by the Cincos themselves) than the building of their five homes on the Camino del Monte Sol. Until 1917 it was referred to as Telephone Road, because of the telephone lines which were strung the length of the road to Sunmount Sanitorium a mile or so to the south. Alice Corbin, offended by the use of the sobriquet, took it upon herself to have its proper name restored—Camino del Monte Sol—and successfully petitioned the City Fathers to do so.

At the time, not one of the Cincos was earning a real income from his art. Bakos was an excellent carpenter and earned money from the sale of his hand-carved doors and furniture. Mruk had retained his job as a forest ranger, Nash had his patron in Detroit, and Ellis painted signs and did finish work on furni-

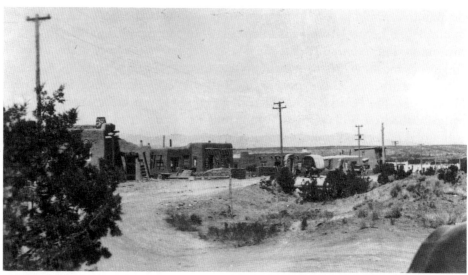

"The five little huts of the five little nuts." The adobe homes of Los Cincos Pintores on Camino del Monte Sol, under construction in 1921. Houses from left: Ellis, Nash, Shuster, Bakos, Mruk. On the west side of the street looking north toward downtown. Photo Archives, Museum of New Mexico.

ture to make money. Shus, who received a small stipend from the government because of his war-related disability, also did ornamental ironwork as his health permitted. It was a craft he had learned as a boy at the Manual Training High School in Philadelphia. Of necessity, all became consummate barterers, trading drawings and paintings for medical services and, sometimes, for groceries. Ashby Davis, one of the early Santa Fe merchants, accepted pictures in exchange for items of hardware critical to the Cincos' home building project.

Shus managed to sell some paintings and took a loss in doing so. He accepted two hundred dollars for work actually valued at four hundred, and cash in hand, promptly announced to Helen that they were going to build an adobe house on the camino. The four others managed one way and another to come up with small amounts of money, and with more enthusiasm than knowledge or skill the eastern transplants began the business of building their adobe homes, side by side, on the Camino del Monte Sol. Frank Applegate, from whom they had purchased their parcels of land, assisted them further by providing tools, laborers, and perhaps a small amount of cash.

Evidently nobody told them that adobe making shouldn't be started in the late fall as the mud bricks need a time in the hot summer sun to cure. The consequence of their zeal to get started immediately, even though it was late October, happily, was amusing rather than hazardous.

Ellis and Shus, who were building their homes adjacently were working feverishly stacking adobes. Ellis saw Shus' wall start to lean in slow motion and hollered to him, "Hey Shus! Your wall is falling over."

Shus looked Ellis' way and hollered back, "So is yours!" and Ellis turned just in time to watch his own wall topple. Despite such setbacks they managed to finish the homes and did the electrical wiring and plumbing themselves.

They came to be called "the five little nuts in five adobe huts," no doubt in reference to their exuberant personalities, their *joie de vivre*, their "wild, modernist" approach to art—but surely also because with little money, skill, or knowledge about adobe home building, the "little nuts" went boldly ahead and built their "little huts." (Six decades later, the "little huts"—actually stunning examples of Pueblo revivalist architecture—command prices of up to half a million dollars each.) By early 1922, all were ensconced in their new homes and the art colony—in the truest sense of the word—was established.

In 1926 the Cincos began to drift apart as a collective artistic unit. There was never any formal disbanding of their group; in fact, they retained lifelong relationships as artists and friends, even when distance separated them. In time, Mruk returned to New York and Nash relocated in California. Ellis, Bakos, and Shuster remained in Santa Fe, and each became a vital component of the artistic community and the community-at-large for several decades more.

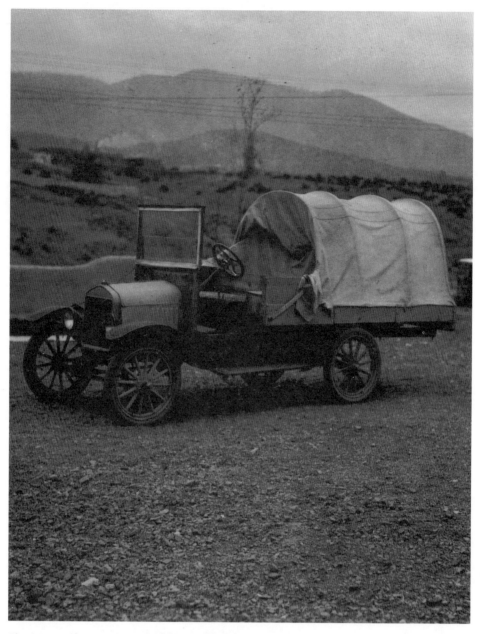

Shus' "covered wagon"—a Model T outfitted for painting excursions and camping trips. A familiar sight around Santa Fe through the 1920s.

4

The Homestead Years

The shrill coyote's call
Under a waning moon
Stirs within me
A yearning
For the warmth
And tenderness
Of a House on a mountain top
Built of wild flowers;
Where once
In silence
Dwelt love,
And now
The eerie call of the coyote
And the solemn hoot of the owl
Leave ghostly trails
Where once a house was built.

—The Poems, 1934

Homesteading. It is a word out of the history books, describing a time when the American frontier was being pushed ever westward by enterprising pioneer families in covered wagons. But homesteading—free land offered by the government in return for settling it—was available to people in Santa Fe through the 1920s. The requirements for homesteading were that one had to file for a piece of land and live on it for three years. After that, the land was deeded to the settler.

Typically, Will Shuster was interested in the concept of being rewarded for self-sufficiency; it struck a chord with his own pioneering spirit. And so in 1929 he and Jozef Bakos decided to stake their claims. They each filed for a homestead and chose tracts of land 160 acres each off what is now Tano Road, a few miles northwest of downtown Santa Fe.

Possessing land on paper was one thing, however, and actually standing on it was quite another. Shus, with Helen and Donnie in tow, had to make several trips out into the barren and puzzling high desert even to locate what was theirs. The government agent had told Shus that each of the four corners of the property was marked by a pipe with a flat top and the top was supposed to give specific directions on how to find the other corners. That sounded easy enough, but first you had to find one pipe.

Several excursions were necessary before Shus found a marker. Eventually, with everyone searching, the entire large plot became apparent. But on the next visit, after the winds and weather had swept through, the look of the place had changed a bit and they had to go through the locating process again. At one point Shus offered a cash reward to family and friends for finding the pipes.

By the end of the 1920s Shuster was comfortably fixed and in a positive frame of mind. His paintings were selling well, earning him a reputation that allowed him to increase their dollar value somewhat, and his wrought iron work was sought after. He was always ready with ten ideas for creating things and making money from them, but now the wolf was safely away from the door.

In 1930, with the land identified and christened the "Crazy Bear Ranch," Shus began to think of forging a road into the property. He rented a plow and went to work. Helen was enlisted to drive the family's Model A Ford, Shuster hitched the plow to it, and together they dug out a road following the ridge lines.

From the moment he decided to file on the homestead, Shus applied all his creative energy to the project. It was decided that the family would move out in the early Spring of 1930 and initially live in a ten-by-twelve foot shack to be made of the lumber that would eventually become the roof of the main house.

The primitive phase of the homestead lasted five months. Helen and Shus slept in the shack, which had a large kitchen stove for cooking; Don slept on a cot just outside the back window. During this time Shus, with the help of a couple of Indian friends, constructed the watershed and the cistern, the primary water supply, while work progressed on the main house.

The house itself was to have all the amenities of a city dwelling, including running water and electricity supplied by a gasoline-powered generator. Shus built a chicken house and corral with the idea of supplying the family's larder. Self-sufficiency also extended to rabbit-hunting expeditions.

The name Crazy Bear (*Ki-tay-wee* to the Indians, from whom it derived) alluded to an old story Shus had heard from the Indians of the nearby Tesuque

The Shuster Family at the Homestead in 1933: Shus, Helen, and Don with family pets.

Pueblo. Long ago a bear had started preying on Tesuque livestock. Each time it made a visit to the pueblo, the irate Indians chased it across their land until it disappeared past a certain hill. Once they stalked the bear to the hill and found it perched in one of the tall pines that stood there. They killed it, and the great hairy animal fell to the ground with a thud. But when the Indians examined their catch, they found it was a San Ildefonso Indian dressed in bear skins.

When the story got around, it was the San Ildefonso Pueblo that claimed a crazed Tesuque Indian dressed as a bear had been stealing from their flocks, and that they had put an end to him on the hill.

Whatever the circumstances, the hill was given the name Crazy Bear, and Shuster, when he took over the homestead land that included the celebrated hill, kept the old Indian name.

Water was of paramount concern at the dusty, isolated homestead. A well was out of the question because it would have been financially prohibitive and otherwise too laborious to dig to the depth necessary to hit water. The concrete watershed collector managed, but just barely; from time to time, especially when there was little or no rain, Shus had to go into town and haul home seven hundred gallons on a water wagon. Rainfall of any quantity was cause for a huge celebration.

The first extended period for the family at the homestead was that seven-month stay through the summer and fall of 1930. Donnie had contracted pneumonia earlier, and Shus and Helen decided to take him out of school for a year. Recuperating on the homestead would become a pleasant memory for him and an adventure in pioneer living.

John and Dolly Sloan were frequent visitors to the shack (in fact, one of Sloan's paintings shows the cozy interior of the place), along with Bakos, who owned the spread just east of the Shusters' land. Eventually Sloan also homesteaded a plot and called it "Sin Agua"—Without Water—but he spent only brief periods there. Driving west on Tano Road, Sloan's land was first, then the tract belonging to Bakos, and finally Shuster's. The proximity of the painters kept the homesteads from becoming lonely places in the wilderness; their parties, which inspired so much of the life-style of Santa Fe, simply changed venue to the wide open spaces.

Whenever funds got low for Shuster, he rented out the house on the camino and moved the family to the homestead. Such was the case in the early 1930s, when the effects of the Great Depression had begun to be felt in the West.

In a letter to the "Burro Alley" editor of the Santa Fe *New Mexican* in the spring of 1931, Shus joked that he was looking for a flying car to get to the homestead:

Wanted: an auto giro aeroplane, a set of wings for the old flivver, or the abolishment of one of the most useless detour routes that I have yet to meet up with. Poor old me and all the rest of these here homesteaders out in this neck of the woods find ourselves sure 'nuf out in the sticks. Yesterday I started to town bustin' along in grand style on the highway, when right in front of me I finds a whole platoon of Fresnos scratching up that perfectly good road, right out in the middle of nothing at all. Fortunately the brakes worked and I didn't kill more than six horses and I only lost about 16 heart beats.

Late in the summer it became clear that the Shusters were having a grand time at their wilderness retreat. Here is a tongue-in-cheek item titled "Los Pobladores" from the same newspaper:

Neighboring homesteaders have signed a petition protesting against Will Shuster's practice of sitting alone in front of his shack on moonlight nights and singing. Somebody took a pot shot at him one night under the impression it was a coyote howling.

There are now a fox farm, a rabbit farm and a mink farm in the Pobladores district and Bakos is planning to start a skunk farm in competition with Ash [Ashley] Pond's on the Rio Grande.

There are rumors of a sun-cult on one of the more retired claims where sandals form the principal article of garb.

Dolly Sloan says she and John were thinking about homesteading, but she could never get used to drying the dishes with greasewood and walking ten miles for a tin pail full of bath.

Old Homestead making way for new. The lumber from the old house was used in 1931 to build the roof of the new house.

Shus has tamed a couple of large prairie dogs and trained them to be watch dogs. The shrill piping bark never fails to awaken the homesteader when intruders approach and one would-be robber was badly bitten in the pituitary gland by one of these intelligent little guardians.

The passages suggest not only the high spirits at the homestead, but the jocular nature of how bohemian life was reported in the local press. When Shus writes to the paper, he does so under a charming backwoods persona not unlike another Will of the time; in Santa Fe, Shus was becoming the Will Rogers of the Sangre de Cristos.

Behind the gentle kidding Shuster got from his fellow citizens, however, there was an abiding respect for his own lively sense of humor and a deep admiration for his resourcefulness. During the darkest days of the depression, in the face of some of the worst droughts the nation had seen, the local newspaper reported that Shuster had met the water problem at the homestead with his well-known cheerfulness, resilience, and inventor's creativity.

The other day we were out looking over [Shus's] ranch. He has a plan to beat the high cost of well digging to a fare-you-well. It is so simple, and so generally used in other places that we are somewhat astounded that no one around here has thought of trying it before.

Laying off an acre or so on a hillside, Shus has covered it with a concrete water-catch. At the foot of this drain he has built a giant concrete cistern. From

The "new" Homestead House in 1933, built on a section of land pioneered by Shus in 1929. Donnie and his dog are pictured.

there it is piped into the house for use in the many and various ways that water may be used.

Shuster, with his efficiency expert's mind, had calculated that a rainfall of one inch on one square yard of his concrete drain would yield six gallons of water. "Figure that out on the basis of our annual rainfall over about two acres," continued the newspaper in a congratulatory mood, "and see how often Shus can wash."

His letters got to be a regular feature of the *New Mexican* in those years. Most of the pieces are funny and relate specifically to the local populace. He loved homesteading, but the solitude of it sometimes wore on his gregarious nature; the frequent articles were his way of staying in touch.

Shus encouraged visits. The Christmas card he and Helen sent to a list of 135 friends in 1930 is a whimsical cartoon map to the homestead, bordered with an enthusiastic greeting: "The Shusters at the Crazy Bear Ranch in New Mexico—where they raise dogs, jack rabbits, cacti, pinons, geraniums, juniper berries, coyotes, wild kittys, somebody's horses, sheep and cows, genuine hand-painted pictures—etchings, and a goodly measure of hell. . . . "

In the early 1930s he took to inviting friends out through the newspaper and pretended to be upset when word got around that the road to the homestead house was a mud trap for auto travelers who thought they could tool out to Kitaywee with the ease of driving in the city. "Will Shuster came to town this morning with fire in his eye and brimstone in each hand," the paper noted in a news item,

looking for the person who said he got stuck in the mud coming to town yesterday from his homestead. He says it was a base libel to charge him with getting stuck on that road. He himself had too much gumption to attempt to come into town; instead he sat comfortably at home and watched his new tank filling up with nice clean rain water, and grieved a little because he had not made the tank larger. Of course, he admits, he might have gotten stuck if he had tried to make the trip in, but he didn't.

Water—whether the lack or the sudden abundance of it—was the constant concern at the homestead and a constant topic of conversation in Santa Fe. It was all very well to enter the pioneering mode for a few days or a few weeks, but Shus and the family were living out there all the time. His friends wanted to know how he was able to do it. When asked, Shus made self-sufficiency sound easy.

On my arrival in town t'other day I was greeted by Bert Galt with a handshake, a merry twinkling eye, and an invitation to bathe. Bert did not know that I happened to be a graduate of the late lamented war and on occasions have, with one canteen full of water, made a cup of coffee, brushed my teeth, shaved, bathed and washed out socks in the bath water. I might have watered the geraniums if I had them. If you ever try this, be careful you don't reverse the order. It would be tough on the coffee.

"This morning the sun rose and presented us with a dizzy rainbow in the western sky," Shuster wrote from the homestead near the end of summer in 1933. "I can recall one other time having seen a rainbow in that direction. It was a beautiful silver bow made by the rising moon."

Lyrical flights were common at Crazy Bear Ranch, where nothing impeded the clear observation and appreciation of nature. These were precious years of growth for Shuster—and for Helen and Don, and later for the other two children, Linda and John. But all through this time Shus continued his participation in the thick of the artistic life of Santa Fe. He was a natural gatherer of people, whether for a party or for more serious endeavors.

As a multifaceted artist, he was invited to be an indispensable part of every art group that formed. The Poets' Roundup was one example. Though Shus considered himself only an amateur poet and writer (he later wrote a weekly column for the *New Mexican*), he was included in the important gathering of poetic talents that met annually to read, entertain each other, and enhance Santa Fe with the literary side of its culture.

The Poets' Roundup was an annual summer event that ran from 1930 to 1939 and hosted, in addition to local poets, other lights from the world of letters such as Thornton Wilder, who had just won the Pulitzer Prize for his novel *The Bridge of San Luis Rey*.

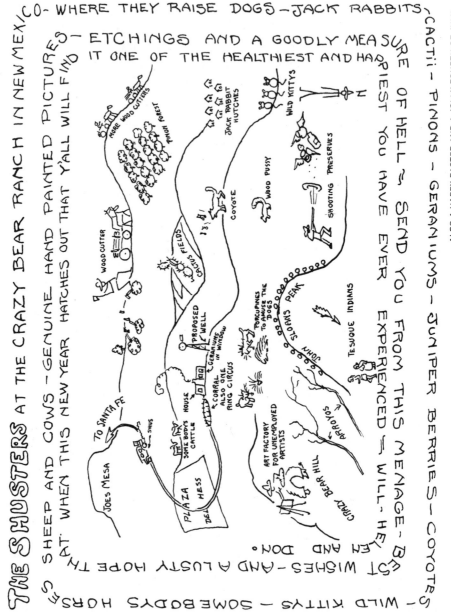

Shus' all purpose greeting card and hand-drawn map to the Homestead for 1930, widely circulated throughout Santa Fe for the benefit of first-time visitors to what is today Tano Road. Courtesy of The Great Southwest Books, Santa Fe.

Witter Bynner and Mary Austin usually led the program, which was most often held in the garden of Amelia White's home on Garcia Street, now the School of American Research, or at Sarah McComb's on Canyon Road, now The Compound restaurant. Over the years the poets who read their poems included Gladys Campbell, Ina Sizer Cassidy, Fray Angelico Chavez, Peggy Pond Church, Alice Corbin, John Gould Fletcher, Dorothy B. Hughes, Robert Hunt, Dana Johnson, Margaret Larkin, Maurice Lesemann, Haniel Long, Grace Meredith, Langdon Mitchell, Lynn Riggs, Earl Scott, Mack Thomas, Stanley Vestal—and, of course, Will Shuster.

Shus was a brooding poet. His short works reveal a melancholy aspect of his personality that he rarely, if ever, showed to the public.

> *No warm glow of friendship*
> *Of nearness*
> *Of you*
> *Cheers me.*

> *My close friends*
> *Take the look of strangers*
> *My house echoes my footsteps*
> *Emptiness—aloneness*
> *Fills me.*

In a selection of his poems written between 1930 and 1938 and read at the Poets' Roundups, Shus bares his soul and gives us some indication of that alternately joyous and troubled period in his life.

> *Waning Moon*
> *And this the slinking moon*
> *That yesterday*
> *Glowed in heart warmths*
> *Filling the white quiet of the night*
> *With endearing whispers.*
> *Tonight, no whisper*
> *Or echo of whisper*
> *Dare speak.*
> *Silence slides down the shadows*
> *And kisses the darkness*
> *Good night.*

> *Evolution*
> *The amoeba that is me*
> *May, as the sun cools*
> *Breed a peacefuller earth vermin*
> *To war, on other peaceful earth vermin.*

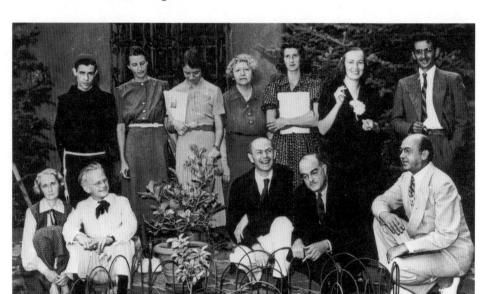

Members of the 1938 Poets' Roundup. Back row, left to right: Fray Angelico Chavez, Peggy Pond Church, Grace Meredith, Alice Corbin Henderson, Janis deKay Thompson (Mrs. Grenville Goodwin), Dorothy Belle Flanagan (Mrs. Levi Hughes), William Pillin; front row, left to right: Josephine Pinckney, Will Shuster, Haniel Long, Thornton Wilder, Witter Bynner. Photo courtesy Clark Kimball, The Great Southwest Books, Santa Fe.

Company

I carry a little death imp on my shoulders
And he is always telling me what to do
I keep telling him to go to hell!
But someday when I'm tired I'll listen to him.
Then he will get a new job.

Words

Words are worthy
Of better things
Than
Are said with them.

Often he turns a meditation on death into a joke, as if trying to cover both sides of his personality. This is "Mirror" from 1938:

That thin silver film which
Reveals my me to me but never my me to you
Is a grim joker.
This important thing which I see as me
Will shortly make a passable
Fertilizer.

Plate 1. Self-Portrait, *1931, oil on canvas, 30 × 24 in. Property of The Estate of Selma D. Shuster. Courtesy of The Gerald Peters Gallery, Santa Fe.*

Plate 2. Helen, *ca. 1917, oil on canvas, 14 × 12 in. Painted in Philadelphia. Property of Mark Shuster.*

Plate 3. Portrait of Helen, *1931, oil on canvas, 28 × 23 in. Property of Mrs. Don B. Shuster.*
Photo by Damian Andrus.

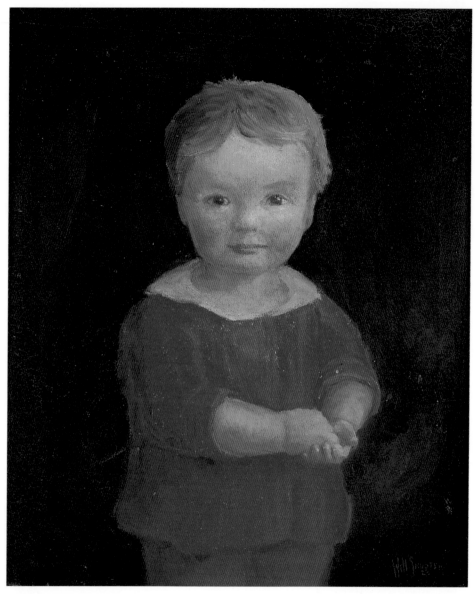

Plate 4. Don at Age 2, *1923, oil on canvas, 44¼ × 29½ in. Property of Don B. Shuster, Jr.*

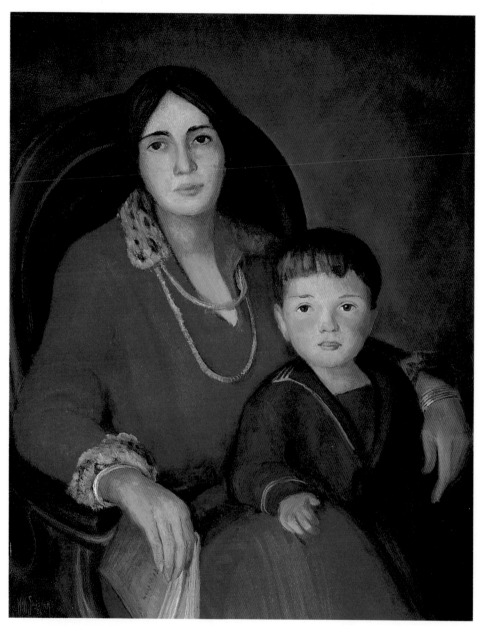

Plate 5. Helen and Don, *1926, oil on canvas, 30 × 24 in. Property of Mrs. Don B. Shuster.*

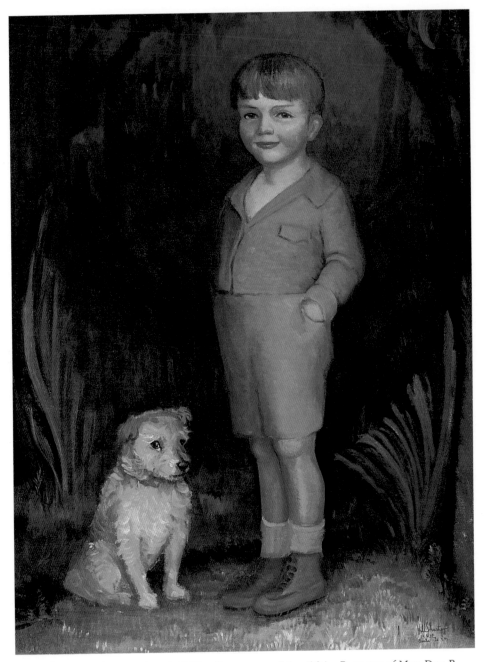

Plate 6. Portrait of Don at Age 6, 1927, *oil on canvas, 24 × 20 in. Property of Mrs. Don B. Shuster.*

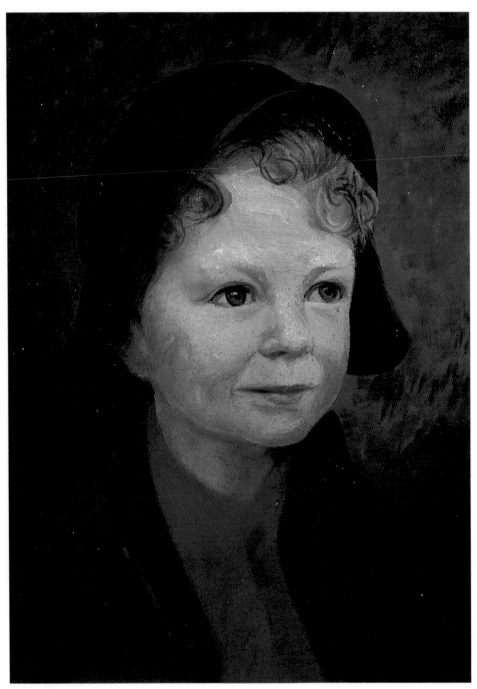

Plate 7. John Adam Shuster at Age 5, *1943, oil on canvas, 16 × 12 in. Property of John A. Shuster.*

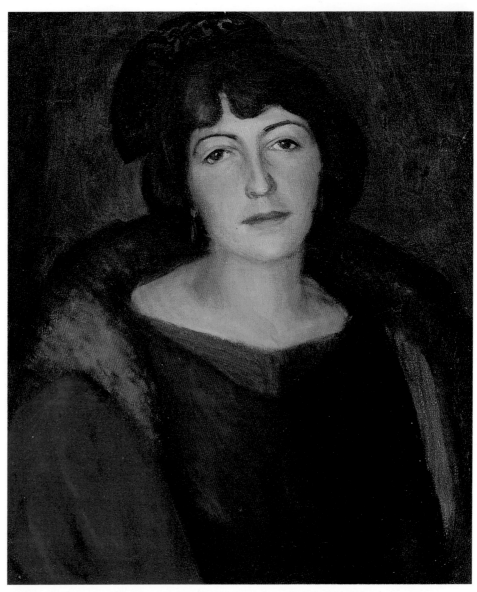

Plate 8. Sami, *1923, oil on canvas, 24 × 20 in. Property of Linda Marts.*

Plate 9. Portrait of Linda. *1943, oil on canvas, 20 × 15 in. Property of Linda Marts.*

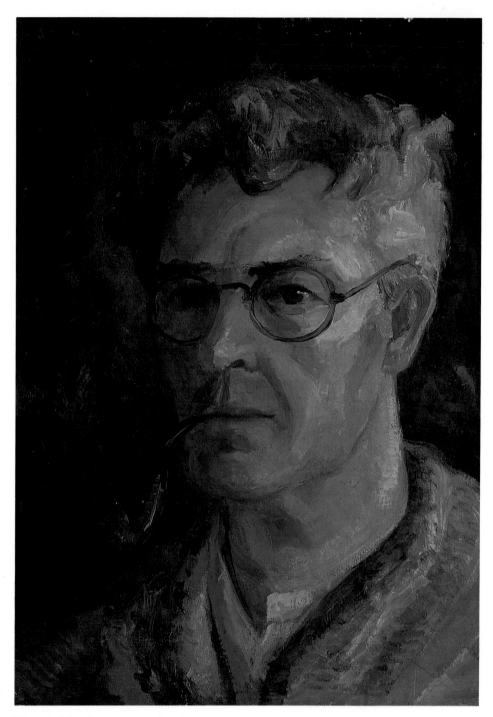

Plate 10. John Sloan, *1924, oil on board, 13½ × 11¾ in. Painted during the famous duel.*
Property of Mrs. Don B. Shuster.

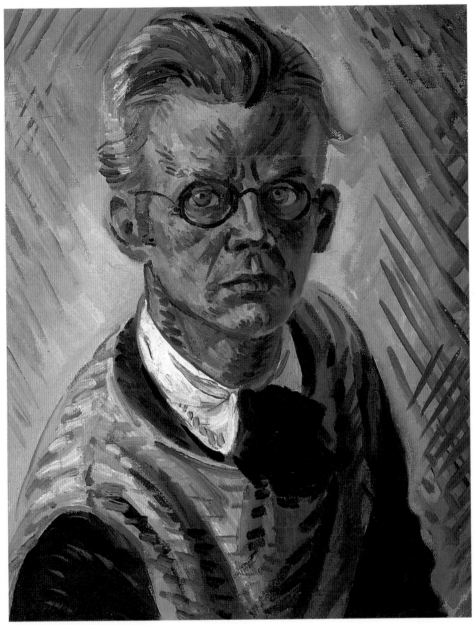

Plate 11. John Sloan, Will Shuster, 1924, oil on canvas, 20 × 16 in. Painted as part of the famous duel. Property of Mrs. Don B. Shuster.

Plate 12. D & RG Station at Embudo, *1944, oil on canvas, 24 x 20 in. Property of John A. Shuster.*

Plate 13. The Laundress, *1920, oil on canvas, 20½ × 16½ in. Property of Mrs. Don B. Shuster.*

Plate 14. Sermon at The Cross of the Martyrs, *1934, oil on canvas, 48 × 36 in. Collection of The Museum of Fine Arts, Museum of New Mexico. Gift of Don B. Shuster, donated in memory of Helen H. Shuster by her family, 1972.*

Plate 15. Penitente Crucifixion, *1927, oil on canvas, 40 × 30 in. Property of The Harsen Collection, Denver.*

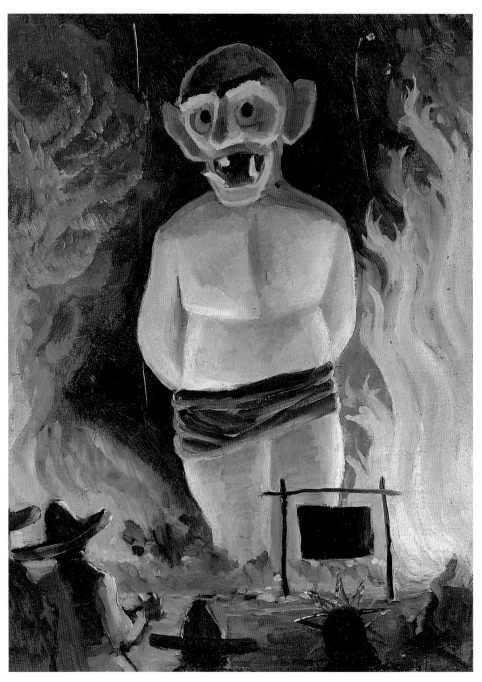

Plate 16. Zozobra—Old Man Gloom, *ca. 1927, oil on canvas, 16 × 12 in. Property of Linda Marts.*

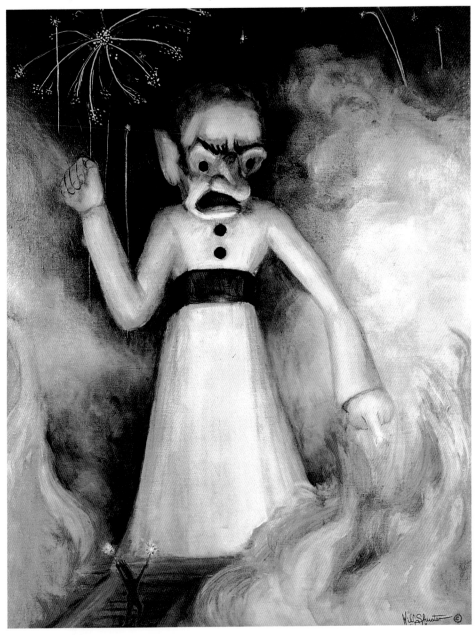

Plate 17. Zozobra—Old Man Gloom, *1953, oil on canvas, 30 × 24 in. Property of John A. Shuster.*

Plate 18. Penitente Women—Eve of St. Francis, *1922, oil on canvas, 30¼ × 40¼ in. Collection of The Museum of Fine Arts, Museum of New Mexico. Gift of Mr. and Mrs. Stephen V. O'Meara, 1983.*

Plate 19. The Blessing of the Woodsmen, *1939, oil on canvas, 20 × 24 in. Collection of The Museum of Fine Arts, Museum of New Mexico. Purchased by the Museum of New Mexico Foundation, 1966.*

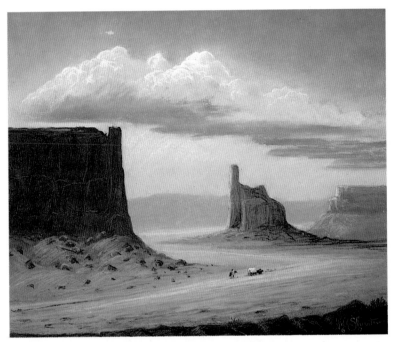

Plate 20. Monument Valley, *1960, pastel on paper, 20 × 24 in. Property of Mrs. Don B. Shuster.*

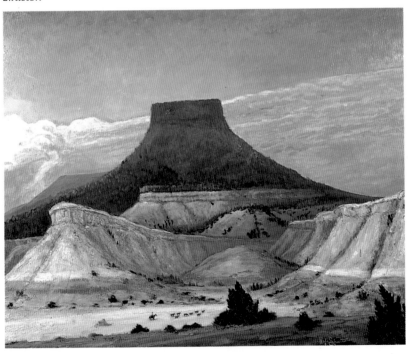

Plate 21. Lofty Pedernal, *1964, oil on canvas, 24 × 30 in. Property of John A. Shuster.*

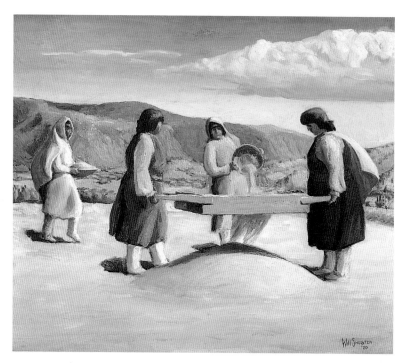

Plate 22. Sifters, *1920, oil on canvas, 20 × 24 in. Collection of Clark Marlor, Brooklyn, NY.*

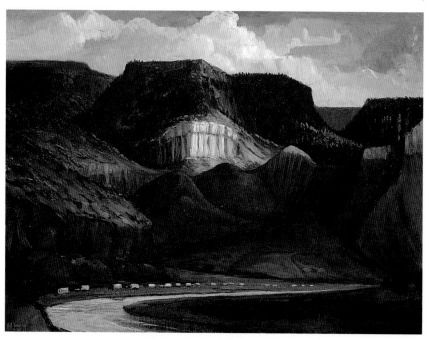

Plate 23. Chama Canyon—The Wool Train, *1923, oil on canvas, 36 × 48 in. Property of Linda Marts.*

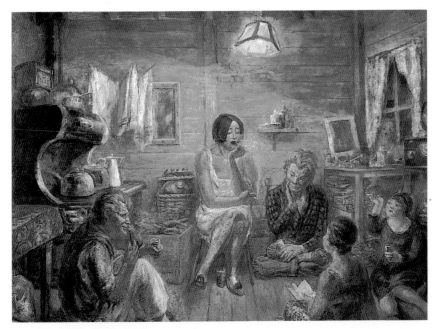

Plate 24. John Sloan, The New Homestead, 1930, *tempera and oil varnishes on panel, 24 × 32 in. Property of Helen Farr Sloan, Delaware, RI. (From left: John Sloan, Helen Shuster, Shus, Helen Farr "Pete," Dolly Sloan, and Donnie peeking through the window.)*

Plate 25. The Queen's Chamber. *1934, oil on canvas, 30 × 30 in. Property of Mrs. Don B. Shuster.*

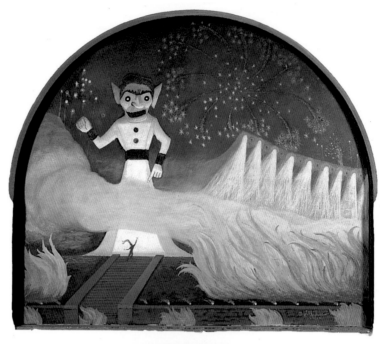

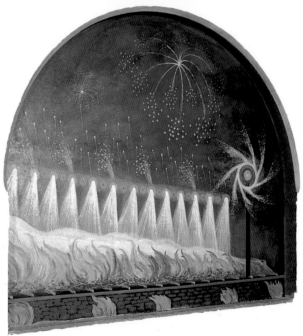

Plate 26. The two murals at El Nido Restaurant, Tesuque, New Mexico, were commissioned by Mr. Ray Arias in the mid-1960s. They are the property of Mrs. Irene A. Walker. Shuster decided to paint the murals on stretched canvas with oils so that they would be removable. He had seen many other artists' murals painted over.

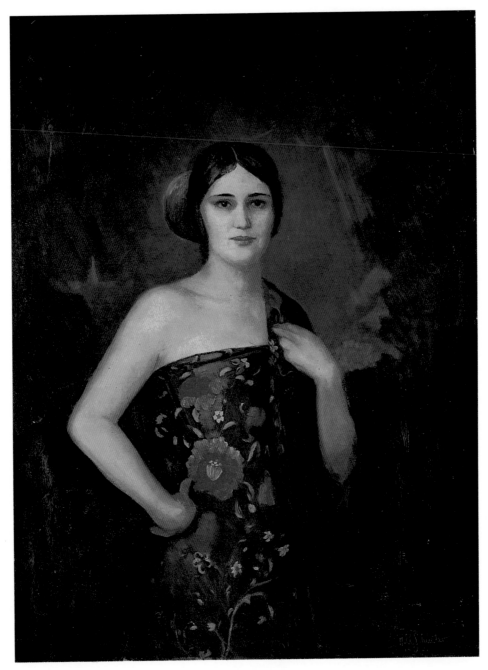

Plate 27. Laurencita Gonzales de Ellis, *1927, oil on canvas, 40 × 32 in. Courtesy of The Gerald P. Peters Gallery, Santa Fe.*

Plate 28. Foothills, *ca. 1925, oil on canvas, 20 × 22 in. Courtesy of The Gerald P. Peters Gallery, Santa Fe.*

Plate 29. New Mexico Storm, *1946, oil on panel, 30 × 24 in. Courtesy of The Gerald P. Peters Gallery, Santa Fe.*

Plate 30. Formation on the Rio Grande, *1923, oil on canvas, 30 × 40 in. Courtesy of The Gerald P. Peters Gallery, Santa Fe.*

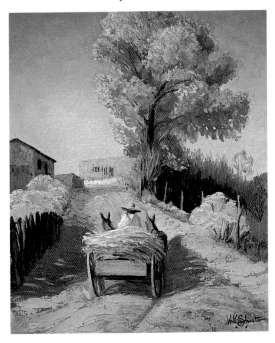

Plate 31. Cottonwoods in Tesuque, *1946, oil on panel, 20 × 16 in. Courtesy of The Gerald P. Peters Gallery, Santa Fe.*

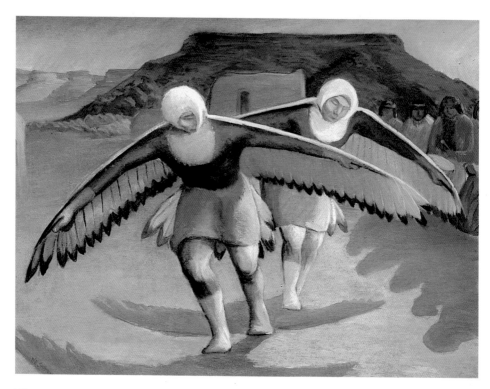

Plate 32. Eagle Dance, 1922, oil on canvas, 30 × 40 in. *Courtesy of The Gerald P. Peters Gallery, Santa Fe.*

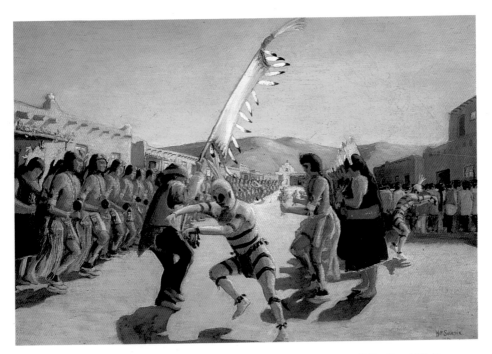

Plate 33. Corn Dance, *1920, oil on canvas, 26 × 37½ in. Courtesy of The Gerald P. Peters Gallery, Santa Fe.*

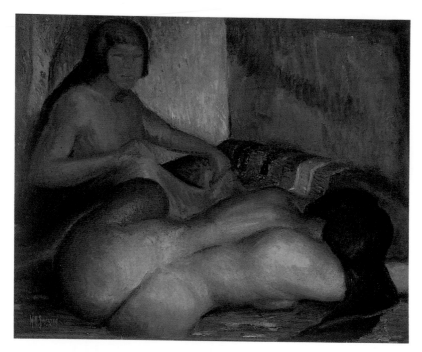

Plate 34. Untitled Nude Study, *1924, oil on canvas, 24 × 29½ in. Courtesy of The Gerald P. Peters Gallery, Santa Fe.*

Plate 35. Merry-Go-Round, *ca. 1928, oil on panel, 24 × 18 in. Courtesy of The Gerald P. Peters Gallery, Santa Fe.*

Plate 36. Voices of the Sipophe, *1934, fresco, 68 × 47 in. The Museum of Fine Arts (patio), Museum of New Mexico.*

Plate 37. Voices of the Water, 1934, *fresco, 68 × 46 in. The Museum of Fine Arts (patio), Museum of New Mexico.*

Plate 38. Voices of the Sky, 1934, *fresco, 68 × 47 in. The Museum of Fine Arts (patio),* Museum *of New Mexico.*

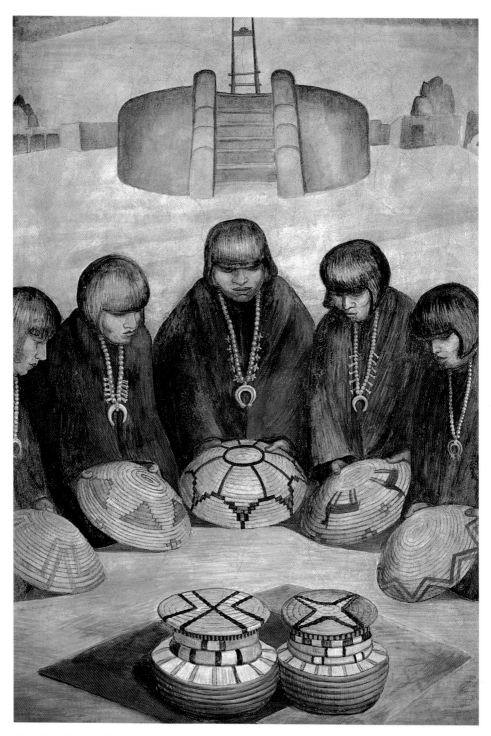

Plate 39. Voices of the Earth, *1934, fresco, 68 × 46 in. The Museum of Fine Arts (patio),*
Museum of New Mexico.

His attitude toward life could be equally ambivalent at times, mixing comedy with the most piercing criticism, as in "What's the Use" from 1932:

> *This world of striving, prating people*
> *Of factories din and churches steeple*
> *Of hospitals and laws and jails*
> *Makes just as much sense as do the trails*
> *Of millions of dogs that chase their tails.*

Shuster was most comfortable in his poetry, and most rhapsodic, when he was out at the homestead contemplating nature and living the unfettered existence of an artist close to the earth. These are excerpts from "Battle of the Ranges," which he wrote while witnessing a spectacular thunderstorm above his ranch:

> *Crazed streaks of fiery light*
> *Strike home and*
> *The pallid cloud blood*
> *Gushes earthward*
> *Blown by the breathing fury*
> *In curving streams*
> *Which wash the earth.*
>
> *Closer and closer, they come together*
> *Hurling dazzling bolts and imprecations.*
> *Now the great grey bellies of the Warriors*
> *Blot out the blue.*
> *The labored breathing of the struggling giants*
> *Shriek and howl with a swirling speed*
> *That robs the heat; and icy corpuscles*
> *Beat upon the earth as*
> *Pinons and junipers*
> *Huddle closer to the ground.*
> *Sharp stabs of crooked light*
> *Strike earthward with the hail*
> *And sheets of rain wash out the sight.*

Then, under the churning turbulence in the skies, the sun breaks through. Shus, the eternal optimist, takes his observation of nature the last step into an embracing calm:

> *Under blue peace the Sangres lie*
> *Wreathed with a rainbow.*
> *Night hawks flutter and swoop and play.*
> *As growing things*
> *Give thanks.*

❀ ❀ ❀

"Following President Roosevelt's advice in his back-to-the-soil movement," Shus wrote in the *New Mexican* in the middle of August 1933, "I am closing up the Crazy Bear ranch and coming back to Santa Fe. . . . I really think it will make quite a change in the economic situation because the bill collectors won't have to travel so far when they come and visit with me, and that ought to save them a nice piece of change, which they can credit to my account. In time the savings made might equal the bills."

Shortly after that the family moved back into town and Shus became involved in the planning of the New Mexico exhibit to the World's Fair in Chicago. He and Don traveled to the Windy City and spent most of the summer overseeing the installation of the exhibit, which included the works of Maria Martinez, the Pueblo potter with whom Shus had established an affectionate friendship that stretched back to his visits to San Ildefonso in the early 1920s.

Shuster returned to Santa Fe and the bill collectors, and there were other problems too. In the next two years the marriage with Helen would sour and they would divorce. "Helen," he wrote in a poem,

> *You whom I have loved*
> *Aye worshipped.*
> *Now we part—*
> *My love is dead.*
>
> *Your speechless love*
> *Lies writhing*
> *In agony*
> *On a frozen altar.*

When Shuster married Selma—or Sami, as everyone called her—in the summer of 1937, the bohemian side of his personality began to recede somewhat. Sami had come from eastern money and did not take well to the strenuous outdoor life of the homestead. Toward the end of that decade and into the 1940s, the Shusters used Crazy Bear less and less often, and when they did, it was for short summer vacation periods.

The children—for now there was Linda, Sami's daughter by a previous marriage, and John Adam, the son of Shus and Sami's union—remembered the homestead as paradise. By then Crazy Bear had a chicken house and a swimming hole, a billy goat named De Vargas and three milk goats, assorted sheep, and friendly wildlife that made regular visitations.

It was a nineteenth-century lifestyle on the homestead, a place where Shus could be exactly the way he wanted to be. Any little event was treated as a provocation to celebration: when the generator worked and the lights went on, there was a party; when it didn't work and the lights did not come on, there was a party.

Helen at the Homestead in 1934, shortly before the divorce.

For ten-year-old Linda, Crazy Bear was a tomboy's dream. Shus taught her all his secrets of husbandry and mechanics and didn't consider it inappropriate for a girl to know how to fix things, including a '39 Plymouth. John, born in January 1939 ("Oh boy! It's a boy!" Shus recorded in his diary), grew up at both the house in town and the homestead, but his most indelible memories would be of times spent at Crazy Bear. Totally at ease, Shus turned even subsistence routines into fun for the children. Summers sped by through the war years.

By 1935, Don had left Santa Fe for the New Mexico Military Institute in Roswell, and came home only on breaks. When he did visit Santa Fe he stayed with Helen, who had remained in the first camino home after the divorce. During the war he was overseas. Then, on Zozobra night, 1945, he raced breakneck to Santa Fe to surprise Shus with his return from combat.

Shortly after that Don and his new wife, also named Helen, took over the stewardship of Kitaywee for a year while Don worked at nearby Los Alamos. Don was given Crazy Bear in 1937 as part of the divorce settlement between Shus and Helen, but it was not until after the war that the title was actually recorded in his name. In 1946 Don and his wife moved to Albuquerque where he joined Sandia Laboratories. Crazy Bear was rented out from time to time, notably to Ernest Knee a well-known photographer and Spanish-style door maker. When Shus found himself short of cash he rented out the house at 550 Camino del Monte Sol and moved the family into the studio behind it. But in 1955, when Don's mother became seriously ill and her medical bills mounted, it was decided that one quarter of the land, including the house, should be put up for sale in order to raise funds. This was done and the new buyer soon built a much larger house onto the original place. A chapter in the Shuster story was closed.

The family effectively stopped using Crazy Bear in 1946. For a few more years it saw occasional parties, mostly hosted by John and the new generation, but the homesteading days were gone forever. Now when Shus found himself short of funds, he rented out all of the home at 550 Camino del Monte Sol and moved the family into the studio. It was easier than picking up the entire in-town household and transferring it to the wilds of Tano Road. Besides, Sami, who had never felt at home at the homestead, was more comfortable on the camino.

Crazy Bear was a small source of income from rent in the late 1940s. By 1955, though, it had fallen into disuse, and neither Shus nor the children had a real interest in keeping the place. It was decided that a quarter of the land, including the house, should be put up for sale. The buyer soon built a much larger house onto the original place. A chapter in the Shuster story was closed.

Much later, in the 1970s, Linda made a trip out to the homestead and felt like a stranger there—it just wasn't the same. Don also felt a heavy sadness on his last visit to Crazy Bear Ranch. He had come back not out of curiosity but with

a mission. On the long desert stretches of Kitaywee, against the majestic mountains, he scattered the ashes of his mother, Helen Shuster.

Don said later that the four-year period the Shusters spent on the homestead was really idyllic. It provided great strength and cohesiveness to the family, setting it back on an even keel until everything began to fall apart toward the end of 1934.

One day in 1985 John Adam, who had been living in the East, arrived in Albuquerque, rented a large, fancy Lincoln Continental, and drove up to Santa Fe to see Sami. His mother, now in her mid-eighties, was impressed with the car, as John knew she would be. He suggested they go for a ride, and during it she took enormous pleasure in toying with the Lincoln's automatic windows and other gadgets.

They wheeled easily around the old haunts in Santa Fe, sightseeing in the town that they had both known so intimately and which had changed so radically over the years.

Driving north, they came to Tano Road.

"Let's take a look at the old homestead," John suggested. Sami agreed, and they bumped over the unpaved road that both remembered as once being practically impassable, past impressive adobe homes that had cropped up over the years. At the crest of the hill that Will Shuster named Crazy Bear more than half a century earlier was the house, much changed, that once had been the homestead.

"I want to go in," Sami said suddenly.

"Do you really think we ought to, Mother?" John asked.

But Sami was already out of the car and on her way to the front door. The owner was surprised to see the Shusters and delighted to entertain them. Slowly, Sami and John made their way through the place trying to locate the homestead of their memories. The building was too much altered for either of them to fix the house's original ground plan.

Outside again, Sami did not seem to be moved by the visit. She returned to the car and waited for her son. But John's mind was back in the past, dwelling on the sheer joy of those splendid days.

They drove off silently, away from the golden light of late afternoon, toward town. Overcome with nostalgia, John remembered that on this road in the heyday of the homestead, he and Linda and Sami, with Shus at the wheel, had composed songs on their way back to Santa Fe.

Picnic in the mountains surrounding Santa Fe, 1922: Shuster in cowboy hat, Helen holding firstborn Don, and friends.

⚮ 5 ⚮
Matters of the Heart

Helen left for a vacation in the East with John and Dolly Sloan.

—The Diaries, September 11, 1934

Alone with a full sense of aloneness and a singleness of responsibility. My pet pigeon returned after three months of absence as if she realized my aloneness.

—The Diaries, September 12, 1934

Helen Shuster's departure for a vacation with the Sloans in 1934 signalled the beginning of a marital separation. She stayed with the Sloans in New York for several months. Shus and Helen were divorced the following year after over seventeen years of marriage. The divorce decree stated incompatibility.

Shus' reference to aloneness seems almost out of character for the Will Shuster whose love of good companionship was a hallmark that long defined him. But it is a private statement, and he consigned most of his private thoughts to his diaries. Sloan was the one person to whom he confided personal anguish, sometimes by letter. His children, by virtue of his closeness to them as father and mentor, knew when he was troubled. Their awareness of his periodic feelings of despair over the years grew with their own maturity and ability to perceive the matters about which adults are troubled. When he turned to the pages of his diary in 1934, Shus was validating his own feelings about the hopelessness of his marriage and the necessity to dissolve it. Fifteen of their seventeen

years of married life had been spent in Santa Fe, beloved by them both and the place where their earliest youthful dreams had been realized. But it was here also that problems developed of an irresolvable magnitude.

For Shus, the memories were bittersweet indeed.

Certainly, Helen and Shus did not lack for sweet, shared experiences. An avid sportsman, Shus often went on fishing and hunting trips with male companions. Tom Ring, a camino neighbor and former big-game hunter, frequently accompanied him to hunt for quail, dove, wild turkey, deer, and elk. One year in the late 1920s, just before Thanksgiving, the two men prepared for their annual turkey hunting trip. While the event may have been pure sport for Ring, a true and clean shot assured fresh fowl for the Shuster Thanksgiving table. To their surprise, Helen and Ring's wife, Lottie, said they'd like to go along on the trip, but they didn't want to hunt—just stay as warm as possible in the car and visit. The foursome took off in the Model T touring car for the Acoma area southwest of Santa Fe. The car was loaded down with the occupants, picnic baskets for a meal later in the day, and the extra guns that Ring always insisted on carrying.

When they arrived at their destination, there was much jocularity between the husbands and wives.

"OK, honey," Shus told Helen. "We'll shoot the sons-a-bitches, but you gals have to clean 'em and gut 'em."

"Sure thing," Helen responded promptly. "Assuming you shoot anything."

With great guffaws, shaking of heads, and questionable remarks about how their women had better take care of the "hunters home from the hill" upon their return, Shus and Ring disappeared into the trees.

Helen and Lottie made themselves comfortable inside the car, wrapping themselves snugly inside their coats. They covered their laps with army blankets and talked, for hours. They became aware of the passage of time (and no return of their hunter-husbands) as the late afternoon chill began to creep into the car.

"Do you think we ought to start worrying?" Helen asked Lottie.

"No," her friend replied. "At least we know they haven't had an accident. We haven't heard a shot all day."

Suddenly Helen's dark eyes widened. "Look!" she whispered, "there in the clearing."

The two women stared at an enormous gobbler that appeared in the clearing, strutting slowly toward them. Helen struggled out of her wraps. "Give me that shotgun," she told Lottie, who was sitting in the back seat. Lottie did as she was told. Helen slowly opened the car door, carefully got out, and took aim. Just as the giant gobbler raised his head after a leisurely peck at the ground, Helen fired. The turkey's head flew off into the distance and his body briefly performed the bizarre dance peculiar to recently beheaded fowl.

A short time later, the "real" hunters appeared home from the hill, as

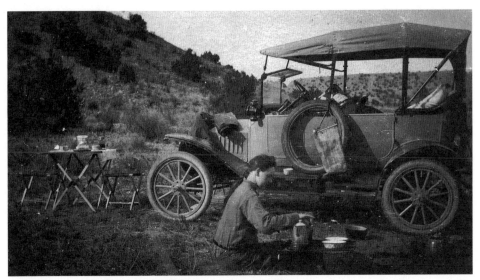

Helen making breakfast on camping trip in the early 1920s.

promised, but empty-handed, save for their weapons. They approached the car where the women had managed to string up the bloody, headless turkey. They stared and neither said a word.

Helen brushed at the dark bangs across her forehead and planted her slightly built figure in front of Shus. "Well," she announced, "we shot the sons-a-bitches. Are you 'gals' ready to clean 'em and gut 'em?"

The joke on himself, nobody laughed quite as hard as Shus as he planted a kiss on his wife and shucked his hunting jacket. He rolled up his sleeves and got ready to clean 'em and gut 'em.

Helen and Shus worked side-by-side as a young married couple and the rewards of their shared responsibilities were tangible ones. In the early Santa Fe years Shus learned etching and designed Christmas cards. Some were custom designed for a select clientele who wanted their own homes featured as the subject matter for the card; others were exquisite examples of generic area scenes or architecture as they appeared at Christmastime in and around Santa Fe. Snow gently mounded along the soft contours of adobe walls or rooftops was a favorite example of local scenery that people wanted for their Christmas cards. Producing the cards was a Shuster family affair: Shus created the designs and pulled the proof, Helen inked, and their son Don, even as a little boy, helped out as the wiper. In time, Helen learned to pull a proof as well as her husband. The income generated from the seasonal sales was often substantial and contributed significantly to the Shuster coffers.

Helen Shuster was her husband's most avid supporter. His causes were her causes, his projects became her projects. She lent moral support and frequent physical assistance. She worked for him and beside him. She worked at jobs

away from home when a supplementary income was necessary. When they built the homestead, one of her jobs was to drive the Model T with a plow hitched to it which Shus steered. Together they "paved" the road that led to the homestead. She stacked adobes with Shus and the other Cincos when they built their Camino del Monte Sol homes. She became secretary to Mary Austin, the venerable Santa Fe writer. In a letter to Sloan dated October 21, 1926, during one of their extended stays at the homestead, Shus detailed a happy family scenario:

> Helen I think looks much better than she has ever looked out here and is in good spirits. She has settled down to the business of running the house, being Mrs. Austin's secretary and printing Christmas etchings. I think we have our household finances carved down—at least we have a plan in operation and understanding about them and we are going about the business of making it good.

Near physical catastrophes often turned into events of great hilarity in the Shuster household, with one spouse being the observer of the other's getting into—or out of—scrapes that frequently involved the Model T.

Very soon after their arrival in Santa Fe, Helen decided that she wanted to learn to drive. With Shus as her instructor by her side, she practiced driving the car around and around an area behind the Sloans' house on Garcia Street. Perhaps prematurely, she told her husband, "I'm read to do this solo."

Always an adventurer but rarely a fool, Shus replied, "Helen, are you sure? You've only driven this little area here behind Sloan's. I'm not comfortable with you driving on the streets yet. And especially by yourself."

"Oh, I don't mean on the streets," Helen assured him. "I just want to drive by myself right here where we've been practicing."

Reassured, Shus gave the go-ahead and, relinquishing his role as instructor, became the interested spectator.

Helen drove the Model T several times around the area where she had practiced and gave Shus the thumbs up sign each time she passed him. On the fifth or sixth pass, Shus noticed a subtle change in the sound of the engine, and this time there was no reassuring thumbs up from his wife. There was, however, a look of extreme consternation on her face. He realized that her speed had accelerated and that she was beginning to panic. She couldn't stop the car. She came around again.

Cupping his hands around his mouth, Shus shouted, "Choke the son-of-a-bitch, honey! Choke it!"

She did, but not until she had, in her panic, abandoned her practice route and driven straight into the Sloan garden, where the Model T gasped and bucked and finally stopped just a few inches short of the trunk of Sloan's favorite pear tree.

Shus moseyed over to the car, planted his foot on the running board, and looked in the window at a white-faced Helen.

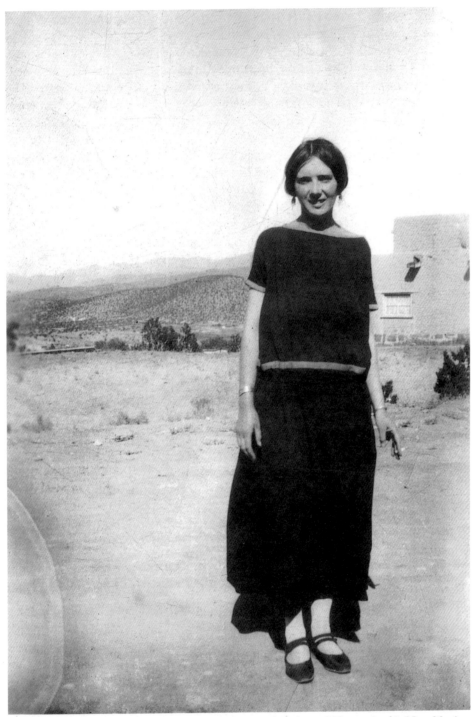

Helen on Pajarito Plateau in mid-1920s, a few years after she and Shus arrived in New Mexico in 1920.

"Well," he said, "I see you're OK. And you didn't quite kill off the car here. Just about choked the life out of her, though."

At the Shuster household, early morning activities were not confined to the relatively simple rituals of rising, dressing, and having breakfast. The Model T figured prominently in getting the day underway. Before Helen started the preparation of the weekday fare of cream of wheat and toast, Shus had commandeered the tea kettle, heating water in it to pour into the car's radiator, which was drained nightly during cold winter months. It was necessary to hand-crank the vehicle after the radiator was filled, and it would buck and kick during the process. Although careful to avoid the protruding crank most of the time when the car predictably bucked, Shus was careless one morning and didn't let go in time. The crank severely wrenched his arm.

Helen and Don watched through the window as the husband and father rose painfully from the ground, stood a moment clutching his arm, then walked resolutely toward a pile of scrap wood nearby. He selected a short piece of two-by-four, returned to the car, and gave the radiator a few hard whacks. "Take that, you SOB," he was heard to shout at the offending car, as he tossed the two-by-four away.

He came into the house, his cheeks pink and his round wire-rimmed glasses misted over from the cold. He blew on his clenched fists.

Helen spooned cream of wheat into a bowl. "Did you get even?" she asked as she handed him the steaming bowl.

"Damn right," he answered and sat down to have his breakfast.

Helen and Don grinned at each other, but didn't laugh aloud.

Shus brooded for two or three minutes and then started to chuckle and shook his head. "Now there's a damn fool for you!" he announced to his family. By nightfall the story had made the rounds of the town, told and embellished by the perpetrator himself.

In early June of 1934, three months prior to Helen's departure for New York, Shus penned an unhappy entry in his diary: "Helen lit and off on one of her terrific jealous scrapes. The same continuing all day of the 6th, which was consequently a complete loss for work. A sad day and a total loss."

Helen, for several years prior to this entry, had manifested evidence of disturbing problems with alcohol. She was given to binge drinking, usually on a solitary basis. The fact that the Shuster life-style often included riotous parties that sometimes lasted from nightfall to sun-up and into a second or even third day evidently had little to do with her drinking patterns. Her difficulty with alcohol was rarely in evidence when she and Shus hosted parties or when they were guests at a social gathering. In fact, she was an enviable hostess and cook and loved to entertain. She conversed superbly with her guests on a variety of subjects.

But emotional and personal issues were another matter. These she held in, brooding upon them, building them into grievances and intimate affronts which imploded upon her own psyche and, finally, with the help of alcohol, were vented aloud, always at her husband and sometimes lasting for days.

What precipitated these emotional, wrenching upheavals which most often occurred in the Shuster home, specifically in Helen and Shus' bedroom (located under their son's bedroom, where he couldn't help but hear his parents' remarks), was an almost compulsive possessiveness on Helen's part. Shus was her man, and the father of her children, one dead in infancy and buried at Bandelier, the other her son, Don, who recalls being treated very much like a possession sometimes.

Father and son were tended to and cared for with a solicitousness that bordered on fanaticism from time to time: no hamburgers at the family table, but plenty of spinach. Helen welcomed their Indian visitors from nearby pueblos who were Shus' particular friends, but worried about dirt they might bring in or bedbugs they might leave behind lest either pose a problem to Shus' health.

However, these manifestations of her possessiveness were truly secondary. While she might be involved in a fascinating conversation at a party with Randall and Florence Davey and the Sloans, to whom she felt particularly close, she was ever aware of where Shus was, what he was doing, and to whom he was talking. If he disappeared for a stretch of time that she considered too long, she had another drink, continued her conversation, and began her solitary anguish. The party over and again at home with Shus, her drinking might continue, privately, for the rest of the night or into the next day. Then the pent-up fury, accusations, tears, recriminations, and litany of slights real or imagined began: He had slept with another woman; he wanted to sleep with another woman; he'd been having an affair with so-and-so, or wanted to have an affair with so-and-so. What was he doing on the patio with what's-her-name for two hours? Had he been kissing "her" again, in full view of everybody? Then the name calling, and Helen's references to her humiliation, hurt, and rejection.

Shus did not defend himself to any great extent during these heated and exhausting confrontations. A standard remark to his wife was, "You're just tight."

"No, Shus, not tight. Just tired," was her usual rejoinder.

What Helen was tired of she never made clear. Perhaps it was the draining fatigue that resulted from the intensity of her fury and the verbal tirades leveled at her husband. Perhaps she was weary of the vigilance she imposed upon herself as she attempted to validate the accusations of infidelity of which she accused Shus. Maybe she was tired of the self-torment brought on by her own excessive, solitary drinking. If the darkness and ferocity of the harangues were unjustified, perhaps Helen's concerns about other women were not.

Shus had a roving eye.

"Well, of course he did, and we all loved Shus!" said a longtime Santa Fe resident, a writer, who was herself half in love with him. "But I didn't have an affair with him. I don't know if anybody did. He was a grand flirt. Sometimes his flirting would be, you know, old-world and courtly. Other times it would be slightly outrageous and funny. He was a little guy, but when he wrapped his arms around you, you felt like you were being hugged by Douglas Fairbanks!"

With tongue-in-cheek another Santa Fe friend said, "TB patients are in a fever all the time and that's an awfully good reason for chasing." Yet another observation was that "his roving eye was part of his ebullience. He had little things going with a lot of women."

Whether Shus considered his relationship with one Thayer ("Budge") Painter a "little thing" or a serious affair was not a matter he confided to anyone. During most of 1935, she rented the Bakoses' house while they stayed at their homestead near the Shuster's own country property north of town. She was therefore a camino neighbor and an active member of the neighborhood social life.

Following the Shusters' divorce, Budge left for Tucson. Shus left Santa Fe, too, and no one but his closest friends knew where he had gone. In time it came to be known that he, too, had gone to Tucson, where he had been commissioned to build a house—for Budge Painter.

He stayed in Tucson for most of 1936, one of the years for which there is no diary. It was also during this time that there was virtually no correspondence between Shuster and Sloan. It is possible that the Sloans made an attempt to "keep a distance" from what was going on in Shus' personal life during that year. As hosts to Helen prior to the divorce, they were sure to have been privy to her confidences during her extended stay with them.

Shus returned to Santa Fe, probably late in 1936, and in 1937 he resumed his journal keeping. For the week of January 31 through February 6 various notations were made concerning errands to do and appointments to be kept. Penciled in large, childlike, irregular script is the name SAMMY, and it is scrawled through the other notations that run the length of the page. The name is circled. On the following page the entry for Monday, February 8, 1937, is brief:

"Letter to Budge—Exit Budge."

Enter Sammy.

❀ ❀ ❀

Selma Dingee Schaumann—Sami (as she preferred her nickname to be spelled)—was not a newcomer to Santa Fe nor to Will Shuster's life in late 1936 and early 1937. She had visited the city in 1923, only three years after Shus and Helen had arrived. She had stayed in Santa Fe for a period of a few months at that time and had taken drawing lessons from Shus. Years later she confided to her daughter Linda that she had had an affair with Shus the first day she met him, but Linda questions the validity of her mother's claim. "Mother talked a

Shus, Sami, and their son, John Adam Shuster, in 1942 at the second camino house.

good line when it came to free love, but she was really something of a prude." It is possible, though, that Helen's concerns regarding Shus' "roving eye" had foundation as early as 1923.

Sami was the daughter of a wealthy Brooklyn entrepreneur who conducted his various businesses from his bed. Paralyzed by arthritis, he had his clients visit him in the "office" of his home—an entire floor given over to his business needs. A male nurse was in constant attendance, and Sami's mother, unable to deal with the home situation for any sustained length of time, frequently left the home for vacations of varying duration. Sami grew up in a privileged environment, monetarily speaking, but had little access to either parent and believed that nobody loved her except, perhaps, the cook. As if to prove her own self-worth, she sold pots and pans door-to-door to the utter dismay of her father, Jesse Tyler Dingee. She was strong-willed, eccentric, and independent, the latter probably out of necessity. These characteristics escalated as she grew older.

Sami came to Santa Fe in 1923 with a friend, Victoria Ebbels. A former student at the Art Students' League in New York, she had no doubt heard from teachers and other students of the small and exciting art colony in the West. Once in Santa Fe, they were enamored of the bohemian life they found. They were young (Sami was twenty-two or twenty-three), pretty, and members of the

flapper era; they slipped into the social structure of the town with ease. It is uncertain how long they had planned to stay, but their visit of a few months was cut short when Sami's mother sent word for her to return home. Her father was critically ill. She returned to New York.

In the summer months of 1923, she received a flurry of impassioned correspondence from Santa Fe that exhorted her to return and "build your house with mine." One letter is signed simply "W."

> Two finished paintings on the easel, one of them being the one I started the day you painted too. You are in it—drying after a swim—I am there, too (but not in the canvas). I'll paint a better one on our honeymoon. I wish I could make the water sing with joy as it would just to have your body near it.

And another:

> I am offering now my humble prayer for your Father's recovery to his world so that you and your Mother will be happy. And when you come to me, your mother will be strong enough to give you to a dreamer. My darling, darling Selma—Beloved One.

The writer is Willard Nash, one of the Cinco Pintores. Six months later he wrote to her, infuriated at her having assumed no responsibility in their relationship. There is no further correspondence that indicates either dissolution or continuance of their summer romance.

Nearly a decade and a half passed before Sami returned to Santa Fe. By 1928, her parents and her sister had died, leaving Sami and her brother Tyler as the surviving Dingees. In 1930 Sami married Leslie Gordon Schaumann and bore one child, Linda Paddock Schaumann, in 1931. Her inheritance enabled her to purchase a home in Connecticut which served as a kind of headquarters for Sami and shelter for Linda and her father. Early in her marriage Sami exhibited evidence that, like her mother, she did not cope well with adversity. Sami's husband was a World I veteran disabled by blindness in one eye, and her inheritance substantially contributed to the family income, a fact that she resented. As well, motherhood was difficult for Sami, and Linda recalls being sent to camp at the age of three. Sami's inheritance eased the way for her to take periodic vacations that distanced her from what she evidently considered a confining home situation.

Her return to Santa Fe, probably in late 1936, likely coincided with Shuster's own return to his home from Tucson. He lived in an apartment on El Caminito not far from Helen's house on the camino.

The winter months of 1936 and the winter and spring of 1937 were busy ones for Shus who, according to his diary entries, alternated his time between courtship and work. The entries, however, are not lengthy or comprehensive:

"dinner with Sam;" "made cast for Varese's head;" "sketching at San Ildefonso;" "dinner at Julia's—missed Sammy;" "Sammy helped clean;" "made new mold of Eagle Dancer;" "meeting of Museum policy committee—Vierra"—such are typical brief entries of the time. But several notations, despite their brevity, provide the basis for a Shuster-Schaumann mystery that the surviving members of the Shuster family are unable to explain:

February 20, 1937: Cast Sam's ring.
March 3 and 4, 1937: "1st Anniversary" [A large heart is drawn around the dates.] "Sam. License."
March 27–March 31: "Carlsbad Caverns-El Paso trip."

Were Sami and Shus married privately or secretly on their trip to El Paso? Were they in fact married secretly a year previously, in 1936? What anniversary is indicated by the March 3 notation?

In the meantime, the notations from early to mid April indicated escalated activity by the pair as they made preparations for a trip to the East, Shus to see family in Philadelphia, Sami to see family in Connecticut, and both of them to visit friends in New York.

Shus' stay in the East was an extended one—over two months—and Sami's was even longer. They were entertained by former and sometime Santa Feans, the Sloans among their many hosts. Shus spent time with writers Edgar Lee Masters and Kyle Crichton. Artists George Blodgett, Paul Burlin, and Howard Patterson, who had spent time working in Santa Fe, were among the people they visited. In Stanford Shus met Sami's daughter Linda for the first time. The little girl had become a member of the Tyler Dingee household, with Uncle Tyler and Aunt Dorothy occupying Sami's own home and caring for Linda during Sami's absences. Sami and Leslie Schaumann were legally separated.

At various times during their trip, Shus and Sami were geographically apart. At one point he was in New York while she was in Stanford. His letters to her are the first written indication of the depth of his love for her.

Darling Sammy:
 Already I miss you to beat hell. Damit Sammy I don't know whether you realize how important you have become in my life. I LOVE YOU. You—tender sensitive you. Understanding intelligent you. Caressingly lovely you. Serious kindly you. All of you. I LOVE YOU. . . . Godamit Sammy—I think we can be an almighty powerful influence for the good of this yere world if we keep the ball a rolling in the right direction and I can see no earthly reason why we shouldn't.
 Wrote a letter to Budge Painter in answer to hers. I will hold it for you to read as I want you to understand thoroly [sic] my attitude toward her.
 Now darling, have a good time, clear up as much of your business as you can

and keep tucked around you as snug as a warm blanket on a cold night—my love. It is all around you whether you feel it or not.

> Your
> Shus

A letter to her two days later is equally as loving and once again addresses his hope for a bright future together. But there is one comment that perpetuates the puzzle of their relationship: "Darling, this is the longest period of separation we have had since we were married."

Once back in Santa Fe, he wrote:

> Just called Cally Hay [journalist for the Santa Fe *New Mexican*] and announced my return—thought I had better get the jump on rumor. She asked if I was married on trip. Says I, hell no, wish I had been. Hold that story until I give you the straight of it later. Told her enough to keep her happy—she won't peep.

Shus dined with his friend, writer Rafael Alfau, on the night after his return to Santa Fe. That night, on June 21, he wrote to Sami:

> Darling:
> I have just returned from an evening at Alfaus—went out at 5:00 for a highball—had dinner with them . . .
> First thing this a.m. . . . explained N.Y. attorney's suggestions and steps you had taken. Fletcher Catron [Santa Fe attorney] out of town but will return end of week. He will contact F. and see if he has heard from N.Y.. Said they could start action on 2nd of July if everything was in order and that it shouldn't take more than 3 or 4 days to get the decree. I wish the devil it was all over. I do get concerned about the possibility of something going screwy.

On July 1, ten days later, is penciled the only entry for that week: "Sam's divorce."

Over half a century later, the secret of the early relationship between Will Shuster and Selma Schaumann remains inviolate.

Very publicly, they were married in Santa Fe on July 21, 1937.

GAY MEXICAN BAILE IS GIVEN
FOR WILL SHUSTER AND BRIDE
AT RANCHO ARROYO IN TESUQUE

Will Shuster and Mrs. Selma Schaumann were married late yesterday afternoon at Rancho Arroyo in Tesuque and the wedding reception that followed in old Santa Fe style brought together all members of the artists' colony as well as the old-timers of the city. It was a wedding baile without parallel in recent years as 300 friends of the bridal couple, most of whom had known the bridegroom throughout his 17 years residence in Santa Fe, attended.

The extensive accounting of the wedding which appeared in the July 22 issue of the Santa Fe *New Mexican* detailed the beauty of the garden setting at the home of Mrs. Helene Ruthling and her parents, Mr. and Mrs. Carl Maurer. It also chronicled the fact that

> arrangements for the party following the wedding were made on 24 hours' notice, when the first plans for a small, quiet wedding with a party later in the week were abandoned. The list of guests was made up hurriedly then with yeoman efforts and the assistance of Mrs. Varese and Mrs. Ruthling . . . and the bridegroom . . . trying to reach all friends by telephone. At a quarter of four, with the wedding scheduled at four, Shuster was still at the telephone trying to reach some that he had called previously three times.

Despite the last-minute haste of the preparations, with the groom on the telephone at the eleventh hour, the Shuses were wed.

Sami and Will Shuster with family and friends in the garden at 550 Camino del Monte Sol, ca. 1942. Standing: Don Shuster and Shus; seated, left to right: Mariam Davis (Wyatt Davis' wife), Sami; children on ground, left to right: John Adam Shuster, Joan Davis, Linda Shuster, and Eddie Davis in foreground.

∽ 6 ∽

Bittersweet Years

*Late awakening having had a disturbed sleep. Anger sickens me
and makes me unreasonable.*

—The Diaries, July 25, 1964

The newlyweds settled into Shus' quarters—El Torreon—on El Caminito. They lived there for only a short time, however; in October they moved to 550 Camino del Monte Sol. The house had originally been built by Shus' friend and benefactor, Frank Applegate, and Shus and Sami purchased it just five months later. With Helen occupying 580 just a few doors away, and Don living there when he was on leave from the New Mexico Military Institute, the two Shuster families were in close physical proximity for years to come.

The last years of the 1930s were particularly busy and active ones for Will Shuster the artist. He worked on a bronze cast of the head of the late Senator Bronson Cutting which was placed on display at the Museum of Fine Arts in early 1938. He initiated work on several new paintings and reworked earlier ones for exhibition in local and national shows. He experimented with paint combinations and "discovered that ordinary oil paint mixes well with Sloan's tempera."

Just a few years earlier, in 1934, Shus' penchant for trying and testing paints and colors in a medium unfamiliar to him resulted in an exciting new project: he was commissioned by the WPA to paint frescoes on the interior patio walls of the Fine Arts Museum. He had never painted a fresco. He prepared for the

Shus and Sami moved into the house at 550 Camino del Monte Sol in 1937.

undertaking by reading Da Vinci's notebooks on frescoes, as well as everything he could find on the ancient frescoes that grace the walls of Rome. He learned about the techniques employed by the Mexican painter Diego Rivera, who had executed stunning, larger-than-life frescoes in this country. He invented a simple machine to mix pigments. Then, before he began the project, he executed a small test panel for applying the paint, with his son Don assisting. Soon, the first fresco was underway, and in short order all were completed during those summer months. For over half a century, hundreds of thousands of visitors to the Museum of Fine Arts have enjoyed the Shuster frescoes entitled "The Voice of the Earth," which depict various aspects of the religious life of the Native American Indians of the area.

And always, during the months of the Sloans' annual stay in Santa Fe, there were frequent sketching trips with Sloan in and around the city.

On January 18, 1939, John Adam Shuster was born. The father, bursting with pride and love, hastened home from St. Vincent's Hospital and wrote a late-night letter.

Darling Sami—

I am so happy. So happy that everything went so smoothly and well for my love—so happy that the little feller is a boy and such a sweet little rascal at that. God has certainly smiled on us. Your radiance comes from deep spiritual centers that are awfully close to what we may consider the God force in man. I pray that it shall never dim . . .

There is a great loving road ahead of us right in the midst of a very upset and disturbed world and I suppose there is little we can do about it but to trust in a wise God to iron out the problems and do our own steady little constructive bit. . . .

There are so many small and large frictions—I hope we shall never know them In that terrifically tense and anxious period when you were suffering to give the world this precious little mite I learned again the fortifying power of prayer I shall have to set a pretty good course for myself that he may have a worthy example as a father, a friend and a guide. Between us I am sure we can do a good job of it. I know too that we shall stumble occasionally and make mistakes, but when we do let's have sense enough to recognize them as such and use them as stepping stones to right things. . . .

It is strange that I don't miss you more than I do. I suppose I am happy in the knowledge that you are snugly and contentedly tucked away with the little tupper right at hand being cared for completely and thoroughly by more competent hands than mine. You are not far away. You are closer than ever my darling—all tied up in my heart. I can't explain what you do for me other than to say that you reinforce me, complement me or rather complete me. A steady flow of peace and vision and strength comes to me. The strongest of these is peace.

Damit darling, here it is one o'clock—I must sleep—so nighty-night, darling. I kiss your pillow—I adore you.

Shus

Everyone shared in the Shusters' joy. Helen Shuster, living in the El Zaguan compound on Canyon Road during her recuperation, wrote to the Sloans:

I am living at El Zaguan, very comfortable and I like it, but of course I shall return to my own abode [at 580 Camino del Monte Sol] as soon as I get my artificial leg, which I hope will be shortly.

Of course you have heard about the arrival of the new Shuster baby—they are very happy over it. Say it looks like Shus. Think they have picked a very good name—John Adam Shuster. Would have liked to have gone down to see both Sami and the baby, but it was out for me, slippery pavement and many steps.

Shus, happy in fatherhood, couldn't understand how Sami could bear to be parted from her daughter, Linda, and insisted that the little girl join their family as soon as possible. In June, Linda left the Dingee household in Connecticut and traveled to Santa Fe by train, accompanied by John and Dolly Sloan. For Linda, estranged from her own father, Shus immediately became "Daddy" and she took his name.

That Sami was uncomfortable in the role of motherhood was evident from the fact that she had spent little time with her first-born, consigning her care to relatives. When John Adam was born, he was the responsibility of a succession of maids who lived in the Shuster household. Linda was sent to camp or away to school during much of her preteen and adolescent life, spending only vacations at home. Even during her infrequent times in Santa Fe, she often boarded with the Ruthling family in Tesuque.

Sami often excused herself from family outings at the homestead and checked

into a local hotel for the duration of the family's stay at the country property. Frequent vacations for Sami alone became the norm, and they varied in length from a few days to two or three months. Often, she announced to Shus in the evening that she was leaving the following day. One diary entry penned by Shus shortly after John Adam's birth states, "Sami left on vacation—God Bless Her."

Although many entries over the subsequent years allude to her frequent and often prolonged absences, no further request for heavenly intervention is invoked. Sami's distancing herself from her husband and children saddened Shus, and he was often at a loss to understand why she did so. Her inheritance provided the independence she evidently needed.

Shus meanwhile scrambled for work. "Painted interior of George King's [a local saloon] to make some extra money." The diary entry appeared as an adjunct to "Make some money for Don's school" (New Mexico Military Institute) just a few days earlier. Income from the sale of paintings, while welcome and often a cause for celebration, could not be counted on with any regularity. Shus took odd jobs to augment the family income. He made or painted frames, he assisted friends with home renovation or refurbishing, and he took on an occasional commercial art assignment. He took out bank loans and renewed old ones. In times of extreme financial duress, Sami contributed to the household coffers from her private income. This created anguish for both Shusters. Sami resented having to supplement the income of the second disabled husband in her life, and Shus regretted the fact that it was necessary to secure her financial assistance from time to time. In a letter to her in which he apologizes for a "debauch" of the previous evening, he also addresses their financial situation:

> Darling, while I am at it I might as well tell you that I have been deeply concerned about the financial mess we seem to have gotten into. This damned income tax business has driven home cruelly my complete and almost hopeless inadequacy as a provider. Just think, Sami darling, in a whole year I have contributed so godam little to the family finances. Christ, not even enough to pay one month's bills. This is distressing.
>
> It is true that I keep busier than many so-called successful people and yet what in hell does it mean to the exchequer. Practically nothing. Where we would be without your inheritance God only knows. I hate to think of it. My plans and ideas and efforts I hope will be productive in the long run but facing the cruel facts of my performance of this past year leaves me dangling.

There was, as well, his disability check from the government, part of which was allocated to Helen. Sami may have resented relinquishing part of that money to her predecessor up the street, and she may have further resented the fact that Linda was often the "runner" who made delivery.

Shus treated financial problems, and, in fact, health problems as well, symptomatically, as emergencies that came up from time to time and had to be dealt

with. Money was a commodity which, in his view, simply enabled one to live. He adhered to the philosophy that if it ran out, creative talents had to be applied or new projects dreamed up to bring in some more income. Once the problem was solved, he forgot about it until a new emergency arose.

Despite periodic hardship, the Shuster life-style remained much as it had in the days when Shus was married to Helen. Throughout the 1940s and well into the 1950s, parties were the social outlet for the Santa Fe artists and their friends, and many of them were hosted by Shus and Sami. Like Helen, Sami liked to plan and prepare for social gatherings. However, once an evening was under-way, Sami did not mingle with her guests and converse or join in musical activi-ties or games or recitations. Rather, she retired to the bedroom where, in the words of her children, she "held court." People came into the bedroom to see Sami, to pay respects to Sami, to be counseled by Sami. The guest who over-looked this ritual risked being ostracized by Sami for days, weeks, sometimes months.

"Mother liked to play queen bee," recalls John Adam. "And as we know, there can only be one queen bee in the hive." However, in the Shuster's circle of friends, there was another woman who demanded similar attention. She was Mariam Davis, wife of Wyatt Davis, a photographer, close friend of Shus', and the longtime "voice" of Zozobra. Mariam was Armenian by birth, her dark, brooding good looks in striking contrast to Sami's own fair complexion and high cheekbones. A handsome pair of women, they vied constantly for center stage and were jealous of each other. Predictably their own friendship was on-again, off-again.

At one party in the Shuster home, Sami prepared to go into the bedroom and assume her customary role for such occasions. For some reason Mariam had preceded Sami into the bedroom and pre-empted the chair Sami used to receive her guests. Upon entering the bedroom, Sami observed that Mariam was con-versing with "her" guests. She turned on her heels and went to the kitchen. In a few minutes she returned carrying a Shuster household staple, a large can of stewed tomatoes, which she had opened. She moved across the bedroom to the chair Mariam occupied and dumped the contents of the can over Mariam's head. Shus noted his reaction to this event in an understated diary line, "Large fracas between Sami and Mariam tonight."

Sami thought of herself as a moth that hovered around the light that was Shus. She never found an identity for herself. People were drawn to Shus and basked in his charisma and warmth, in his sense of fun, and in his sincerity and genuine concern for them. She felt herself to be an outsider, always on the fringe of his life, not fully a part of it, and reinforced that position for herself by her frequent absences.

"Mother was smart and even had flashes of financial brilliance sometimes, when it came to her stocks," Linda recalls. "She was very metaphysical, and

embraced a number of different religious philosophies over the years. Daddy adored her for a very long time, but she wasn't much of a lover or companion to him even early in their marriage. And she was very un-motherly."

Despite the evidence that supports the latter remark, the Shusters decided to have another child. Stephen Shuster was born on May 28, 1942, and Linda, eleven at the time, was ecstatic. She had her "own" baby to play with and take care of. Shus himself was delighted to be a father once again. Not quite three months later, the infant was dead, possibly from what is now called sudden infant death syndrome, or perhaps from a fall caused by a maid's mishandling of him. For some time following the baby's death, Sami maintained that the maid, who had performed an abortion on herself during her own pregnancy, had put a curse on the Shuster infant. Shus, grieving privately, wrote in his diary, "Do not sleep well. Trying to pick up life anew."

The need to pick up life anew characterized much of the Shusters' twenty-six remaining years of married life.

> Prayed to God for help and guidance to solve my relationship to life—to become a tool in his hands as he wills, not me. I began this day with a prayer for the will of God to direct my life. Now I shall start an inventory of my faults and see what I can do to correct them.

While not a churchgoer, Will Shuster was nevertheless a deeply spiritual man who in his diaries and sometimes in letters consigned his thoughts to a personal God. When he invoked a prayer, it was rarely in the nature of a request for personal benefaction. Rather, it was a plea for direction as to how he might right a wrong, and, more often, he asked for blessings for family members and friends who were troubled.

Shus came to realize through the years that certain events which troubled him, and about which he sought divine guidance, were precipitated by drinking—his own and Sami's. While alcohol was long a concomitant in the social lives of the Shusters and their friends, its abuse was rarely alluded to unless someone was hospitalized or physically hurt as a result of overindulgence. In fact, most of the time it was a matter of some amusement, or at the very most, eyebrow raising if overimbibing took place publicly. "Got tight—Shus in the dog house" is a diary entry that generally typified Shus' attitude and the attitudes of his friends toward drinking too much. But perhaps because of his experience with Helen, Shus began to look critically at his own drinking patterns, and at Sami's as well. Some of their problems were definitely alcohol-related.

Over a period of years, together and separately, they each joined Alcoholics Anonymous—several times. They stopped attending meetings with the same frequency that they joined, usually as a result of having been invited to a cocktail party, or friends dropping in, or, as Shus noted in one diary entry, because

"Some baby picture!" said Shus of this 1950 photograph of the artist in repose with his "bear" necessities—fixings and hooch.

he had "bought a pint of liquor on way home from fishing with Tyler. Didn't need it, just wanted a drink."

Sami's frequent solitary vacations evidently became a fact of life for Shus, and Shus noted them regularly in his diaries. The entries, in the early years of their marriage, sometimes allude to his missing her and to his wish for her to return home. They are rarely judgmental. Occasionally, however, he reveals his bewilderment: "Sami says she needs another vacation—AGAIN?" And upon her return, regardless of the reason for her need to get away, he invariably jotted, "Sami home. Hooray! Missed her to beat hell."

Marital separations of varying duration, initiated by Sami, troubled Shus, and there is little specific indication of what prompted them. "Sami notified me 9:30 p.m. that she wanted a separation to exist between us—this is a terrible shock and leaves me bewildered and heavy-hearted. Resolved to appeal to the Great Spirit for guidance and to try to remain calm and unruffled." Gone for a month on this occasion, Sami returned and Shus noted, "Sami and I celebrated nothing in particular."

Sometimes their separations were "in-house" with Shus occupying the studio and Sami, the house. Other times Sami asked him to spend a few days at a local hotel so that she could occupy the house by herself.

In 1953, at the age of 60, Shus was temporarily felled by two illnesses. He suffered a mild stroke, followed five months later by a heart attack. On both occasions, Sami was out of town. These episodes frightened them; diary entries reveal an effort by both husband and wife to maintain a calmer life-style and a gentler treatment of each other. They took a trip to Port Isabel, Texas, where they stayed for two months. Their stay was evidently a rejuvenating one for them and included plenty of relaxation and fishing. They were entertained several times by Frieda Lawrence Ravagli, the widow of D. H. Lawrence, who was staying there at the time herself. Shus sketched and painted a series of pictures that variously featured snapper fishermen hauling in the day's catch, oil tankers, and, notably, crabs—he and Sami became fascinated with the activities of the sand creatures scurrying about the beach.

In general, the Shusters traveled together infrequently and Shus rarely traveled great distances by himself. He maintained a lifelong belief that to stay in Santa Fe was to remain healthy and sane, and to leave it was to court the possibility of illness or serious mishap. "Getting away" for Shus was to go fishing as often as possible, usually with his old friends Duane Northup and Chuck Barrows. Shus and his brother-in-law Tyler were also frequent fishing companions.

Tyler and his wife Dorothy, and their daughters Marie and Carol, settled permanently in Santa Fe in 1946. The Shuster and Dingee families were close and shared frequent outings and holidays together over the years. Tyler was a professional photographer whose talents Shus greatly admired. The family bond between them was reinforced by their mutual respect for each other as artists, and if Shus had been pressed to single out a best friend in Santa Fe, it likely would have been his brother-in-law, Tyler Dingee.

On July 26, 1961, Tyler died suddenly. The entry in Will Shuster's diary is captioned with large block letters,

AND THIS THE FATAL DAY
Estes Park—Estes Lake, Colorado

I had caught two nice trout. Memory [Tyler's son-in-law] one. It started to rain gently. The fish started to rise for flies. Tyler was changing from bait to flies. Bridget, his cocker spaniel, was lying at his feet. Tutu, my poodle, was sitting alongside of Bridget looking out over the lake. There had been several sharp claps of thunder in the hills in back of us. Suddenly there was a terrific flash and a sharp report. I saw Tyler fall down backward and Tutu fell over on his side. Three columns of smoke arose about 3 or 4 feet from the grassy surface in back of Tyler. Tyler and the two dogs were as if asleep. The three of them had been killed instantly. Then it poured.

Shus' diary notes the events that followed in melancholy detail—getting authorities on the scene, notifying family members in Santa Fe, and burying the dogs. Then Shus and Memory Cain left for home.

We stopped on the Las Vegas highway opposite Starvation Peak and buried Tyler's glasses and the leashes of the two dogs. . . . This is a sad and symbolic little ceremony and will act as a memory monument for us in years to come.

Shus' personal memory monument to his friend and brother-in-law was that he noted the anniversary of Tyler's death in his diaries for several years to come.

The thousands of pages that comprise the diaries covering several decades of Will Shuster's life address the myriad matters that interested, amused, troubled, and concerned him. He speaks of spending an entire day assisting Linda in the building of a rabbit hutch. He notes that John Adam will require some help repairing his wrecked motorcycle. He shares Don's pride in the boy's first eleven-point buck following a successful deer hunt. Special recipes appear from time to time (paprika is the secret to a successful kidney stew). Hundreds of pages address his concerns about Sami. Ideas for new paintings appear as tiny sketches. Daily letters and phone calls are noted, and the health of the family pets is recorded. Frustration or fulfillment over a completed painting might be indicated by the use of block letters; "PHOOEY!" or "IT'S A PEACH!" reveal how he feels about the finished product he has worked on for weeks.

But his last three diaries—for 1966, 1967, 1968—indicate his growing concerns for his own health. The entries for these years include meticulous details about how to set oxygen levels on the tanks that he required at home to ease his breathing. Blood pressure readings, medication dosages, and reminders to himself that he had a doctor's appointment on a given day are noted. He was hospitalized frequently during these years, and his stays at the hospitals in Santa Fe, Española, and Albuquerque varied in length from a few days to two months. Always, upon his release from the hospital, he penned a brief but telling note: "Glad—oh, so glad—to get home."

Invariably, he went on a fishing trip with his chums Duane Northup and Chuck Barrows immediately after his hospital stays. The tranquillity and beauty of the Rio Grande or the Pecos River or the calm of Santa Cruz Lake restored him, and his diary notations indicate that he didn't particularly care if he caught fish or not. He was happy simply to be alive and able to enjoy the splendor of the magnificent and rugged countryside which he had loved for almost a half century.

Of necessity, Shus slowed down. Pursuits of a quiet nature satisfied him— reading, gardening, fishing, and television watching, especially professional football games and any coverage devoted to NASA's activities in space. Old friends dropped in at least two or three times weekly for an evening's visit. Finished were the parties of old, the parties that lasted from sundown to sunup and more, the parties that became legend in Santa Fe, the parties orchestrated so often by a funny elfin little man with flyaway hair and a floppy bow tie. Perhaps, though, not entirely finished.

<div style="text-align:center">November 26, 1968</div>

WOW! What a birthday party. Kiwanians called and wanted me to have luncheon with them to celebrate the event. Told them I was sorry I couldn't make it. I rested until 4 p.m. but guests started to arrive at 3 p.m. However, they were preceded by my old pal Fremont Ellis.

Champagne flowed all afternoon. Mumm's—Cordon Rouge—and a whole case was used. Guests as well as I can recall follow: Billie Wight, Alice Rossin, Calla Hay, Lorraine Carr, Eleanor Wilson, Fremont Ellis, Gene Dickson, her son Bob and wife, Si Hess, Helen and Duane Northup, Dorothy Dingee, Steve Kerenskey, Carol Dingee, Marie Dingee, George Roy (Martha had a cold), Don Shuster and Mark, Chuck and Mary Barrows, the Rosens, Mary Mulberry, Cyrus Baldridge, Lief and Herb Mueller, Ed and Laura Beckman, Dave Canfield, Gene Moody, Bill and Connie Le May, Ken and Mary, John Conron and David Lent. I did not eat. Everyone said food was delicious. Joe Bakos. Helene Ruthling. Selma sure did a great party job and loved doing it.

The entries for the remainder of 1968 are not substantial. His last entry is for the evening of February 8, 1969—the night before he died.

In late January of 1969, Sami left Santa Fe for a vacation, indicating only that she was going to Arizona. Shus, living ever more quietly, called his friends Mariam and Wyatt early in the first week of February and asked them if they would drive him to the Veterans' Hospital in Albuquerque. He felt the need to be hospitalized, he told them, but didn't feel up to the drive himself. The three old friends drove to Albuquerque and Shus admitted himself to the medical facility there. Mariam Davis recalls that he urged them to stay awhile, not to go. "I'm afraid if you go, I won't see you again," he told them.

He spent a week at the Veterans' Hospital and seemed to be responding to treatment. He visited daily with his son Don and Don's wife, Helen, who lived in Albuquerque. Sami's whereabouts were unknown, but Shus felt himself on the mend and didn't insist that anyone try to locate her.

On Sunday, February 9, Don visited Shus and father and son were conversing, to Shus' great interest, about an experience Don had had while flying that afternoon. Shus was suddenly taken with a violent fit of uncontrollable coughing. His heart stopped. Immediate measures taken to revive him were unsuccessful. He was pronounced dead on Sunday evening, February 9, 1969, at the age of 75.

Don recalls that funeral arrangements had to be postponed for several days until Sami could be located. Someone remembered that she had mentioned Tucson just prior to her departure in late January and it was there that she was finally located. Upon her return, she immediately planned a funeral service to be held at the First Presbyterian Church in Santa Fe followed by a Masonic burial at the National Cemetery.

But first, Sami held court for the last time. Guests were invited to pay their

respects not at the funeral home where Shus' body reposed but to Sami, in the home she had shared with him for almost thirty-two years. The funeral itself was sparsely attended, as it was a "by invitation only" service—a bewildering farewell to the man who, in the words of an obituary writer, "was at the root of Santa Fe tradition" and "one of our most prominent artists and most widely beloved citizens."

Helen Hasenfus Shuster continued to live in the house at 580 Camino del Monte Sol until the early 1950s. She then moved to Albuquerque and lived with the Don Shuster family, working from her guesthouse residence. She was long involved with projects for the rehabilitation of crippled children. She died on April 6, 1972. Her body was cremated and her ashes scattered near the homestead area.

Selma Dingee Schaumann Shuster maintained residence in the house at 550 Camino del Monte Sol. She continued to travel extensively for many years, but in the last several years of her life became reclusive and saw few people. She died on February 2, 1987. Her body was cremated and her ashes placed in Shus' grave.

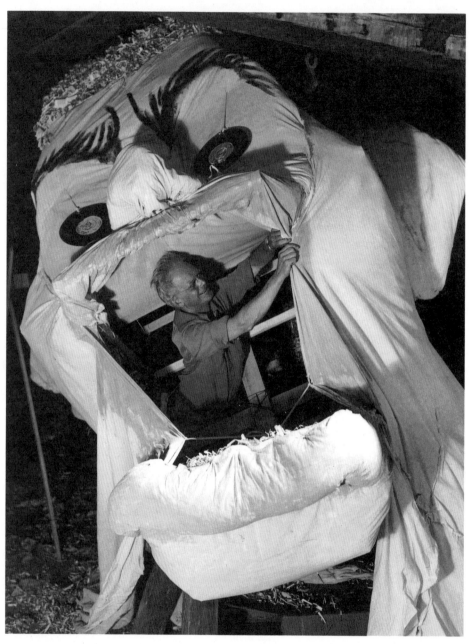

"Old Man Gloom" and his creator during Fiesta preparations in 1947. Photo by Ernest Knee.

7

The Last Fiesta

Fiesta Luncheon—Gate of Spain—12 noon. Arrived late at luncheon—and only by Selma's prodding. Embarrassed. A special decorated Zozo place for me—and luncheon ended when President Jose Valdes presented me with a framed certificate of appreciation. I was deeply touched.

—The Diaries, August 29, 1968

The "Father of Zozobra"—artist, raconteur, inventor, poet, champion of causes silly and serious, rascal and mischief maker, favorite character and gentleman of Santa Fe—was, at almost seventy-five years of age, in somewhat fragile health and suffering from emphysema. Will Shuster was not behind the scenes orchestrating the meticulous details of the burning of Zozobra in 1968. Nor had he participated actively in the construction of the effigy—an exhausting, several days' endeavor which he had captained for almost four decades.

By no means confined or bedridden, but having been hospitalized in recent years and dependent upon oxygen in portable containers to ease his breathing, he had curtailed his own work as an artist. He was obliged to give up many of his civic activities and had delegated the enormous annual responsibility of the building of Zozobra to the Santa Fe Downtown Kiwanis Club. Gardening at his Camino del Monte Sol home and fishing trips with longtime friends had become the favorite pastimes of his later years.

But always ready to enjoy a party—albeit a somewhat restrained version of

the soirees of the old days with fellow artists and friends—the beloved patriarch of the city's art colony was at home preparing to receive guests, who were invited to drop in after the burning "for drinks and a Dutch lunch."

At the urging of the Santa Fe Fiesta Council in 1926, he had created Zozobra to be destroyed by fire in order to dispel the worries and woes of the previous year and give the citizens a reason to celebrate along with their traditional religious thanksgiving for the bloodless reconquest of the city in 1692 by General Don Diego de Vargas Zapata Ponce de León. The editor of the Santa Fe *New Mexican*, Dana Johnson, had discovered that there was a word in Spanish—Zozobra—which meant "uneasiness, uncertainty and gloom." To torch Zozobra was to celebrate the casting off of those weighty fetters.

An avid diarist, Shuster's entries for 1968 revealed his concerns for his community, the nation, indeed the world. Earlier in the year he remarked upon the two senseless assassinations that claimed the lives of a presidential candidate and a civil rights leader. "Ike" was just recovering from a heart attack, he noted. He saw no end in sight to the "police action" in Vietnam, and he noted in an entry just three days before the beginning of Fiesta that the son of a camino neighbor who was covering the Democratic National Convention in Chicago for the *Washington Post* had been beaten by the police and had to be hospitalized.

Newspaper articles in the Santa Fe *New Mexican* provided additional information concerning the local, national, and international scene: the price of sirloin steak soared to $1.08 in the summer of 1968; the public schools in Santa Fe were in danger of losing their accreditation; an angry artist in Truchas spoke out publicly for "hippie rights." Should Canyon Road be one-way or remain two-way? Richard M. Nixon was nominated for the second time as the Republican candidate for president. The people of Biafra starved, the median income for families in this country was $9,670., and if someone remarked that something was "far out" it wasn't linear distance that was being referred to. The real estate section of the local paper advertised a "5-bedroom, Old Santa Fe Style Adobe on 2 acres" for an astronomical $47,500. A musical called *Hair* was making a social statement and causing a scandal on Broadway in New York. And in Chicago "the New Mexico delegation to the Democratic National Convention squabbled among themselves. . . . "

Such were the reasons to put the torch to gloom and doom and celebrate the Santa Fe Fiesta. If people's worries were large, small, serious, unfounded, global, or provincial, Zozobra's raison d'être was to go up in flames to end them.

That is what Shus, a wiry, white-haired artist, bespectacled, short of stature and great of heart, had intended when he began the tradition half a century earlier. With customary modesty, he remarked in an interview in 1966,

"Zozobra just kind of fell into my lap. But every year I tried to see that it got bigger and better."

In downtown Santa Fe, hundreds of people waited for the revelry to begin. The crowd that packed the Plaza in the early fall on the first evening of the city's 256th Fiesta passed the time in varying degrees of jollification and merriment as it marked the countdown for the launching of the three-day marathon party and celebration with the forty-third annual burning of Zozobra, which was to take place at 8:30 sharp.

"Viva la Fiesta!" Three cowboys with powerful vocal chords made themselves heard all the way across the old plaza as they emerged from the bar of the same name on the west side, held their beers aloft for a milli-second, then chug-a-lugged them in several deep, satisfying quaffs.

Emerging from La Fonda Hotel, a contingent on the east side hollered back, "Vivan las Fiestas!" Identically garbed in white trousers and shirts and draped in colorful Mexican ponchos, the four also wore battered straw sombreros over shoulder-length hair. As they downed their own brews, it wasn't possible to tell whether they were male or female, or if both genders were represented in their quartet.

At the corner of San Francisco and the Old Santa Fe Trail, a group of preteen girls stood in a tight circle outside the Capital Pharmacy whispering and giggling among themselves. They might all have been dressed by the same doting mother, for each wore a starched, ruffled white blouse, brightly colored full skirts, and Capezio flats. At least three added inches to their height with perfectly coiffed beehive hairdos. They sucked on cups of lime Cokes or cherry limes and ceased all conversation when boys of their age walked by, whereupon the giggling commenced again with renewed vigor. A handsome pair of youths stopped and tried to begin a conversation with them. Skirts flying, the girls burst into giggles and fled into the haven of the drugstore.

The shouts of "Viva!" echoed from one corner of the plaza to another, as a group of mariachi musicians struck up a familiar Mexican song from the bandstand in the middle of the plaza. Garbs of motley hue swirled past rickracked squaw dresses and bandana skirts and shirts. Men and women in stiff new Levis bumped hips with their younger counterparts who wore bell-bottomed, fanny-patched faded jeans bearing peace symbols.

An elderly Spanish couple sat on a park bench nearby, sipping lemonade, amused observers of the activity and merriment around them. He was dressed in black trousers and shirt, a red satin cumberbund, and a vaquero's hat. She wore a long vintage gown of black brocade slashed with deep velvet pleats from waist to hem, and a fringed lace shawl covered her shoulders. A high tortoise shell comb crowned her silver hair.

The gentleman suddenly leaned toward his wife and whispered in her ear. She turned, smiled warmly to him, and nodded in agreement. He rose from the

Shus and some of his many Pueblo Indian friends, on the Plaza in 1950.

park bench, excused himself, moved to the edge of the crowd and politely made his way through the throng around the bandstand. A few moments later the leader of the mariachi band held up his hand to silence the crowd, then announced, *"Hoy son los cumpleaños de la señora, su marido desea que la canten 'Las Mañanitas.' Sera nuestro placer. Favor de que nos acompañie la gente."*

There was a patter of applause and the crowd, sensing what was about to happen, parted to allow the couple clad in black to pass. The mariachis began the melody and its lovely strains drifted across the plaza.

The couple began to waltz. They moved in perfect, elegant harmony, eyes

locked fondly as they gazed at each other. The circle of spectators was spellbound as a moment from the romance and grace of an earlier era unfolded before them, a nostalgic testimonial to traditions and mores of a gentler time, a time long past, as enacted by the proud and splendid elderly couple dancing a birthday waltz in the costumes of their Spanish heritage. This, too, was Fiesta.

Late afternoon breezes blew gently across downtown Santa Fe, and the silvery leaves of the old cottonwood trees that dotted the plaza shivered in the wake of the light, warm wind. The Stars and Stripes and the flag of New Mexico fluttered from poles atop the Palace of the Governors.

Under its portal, displays of Native American wares spread on the shaded brick walk dazzled all who browsed. The serious buyer or the souvenir hunter had almost unlimited choices and price ranges from which to select items of exquisite craftsmanship and beauty. Enormous and handsome silver and turquoise squash blossom necklaces caught the fancy of some potential buyers, while the more delicate strands of heishi made from olive shells intrigued others. Silver bracelets set with the rich cobalt blue of lapiz were stunning, as were the plain, unadorned belt buckles or pill boxes of gleaming silver.

An elderly Indian woman from Santa Clara Pueblo sat comfortably in a plastic porch chair propped against the palace wall as groups of browsers knelt to examine her display of black clay animal figures and wedding vases. Nearby, another vendor held up a Navajo rug with dramatic geometric zigzag patterns slashed dramatically against a warm grey background.

A dark, handsome young Indian man wearing denim jeans and shirt faded nearly white from many washings explained the process of creating Navajo sand paintings to a cluster of interested tourists who stood before his display. A little boy in the group was far more fascinated by the snakeskin hatband that circled the vendor's wide-brimmed black cowboy hat. Flashing a wide smile, he doffed the hat and handed it to the boy to examine. The boy gave the skin a tentative touch and a wide-eyed stare.

In pairs and groups and singly, people moved to the outdoor food booths surrounding the Plaza. Pots of chile and beans and posole bubbled on hot plates at some booths, onions and hamburgers sizzled at others—pungent aromas assailed the nostrils of old and young alike. The hungry, the taste-testers, the natives, and the tourists queued up for tacos, tamales, burritos, hot dogs, and fiery "bowls of green."

A family gathered before one of the booths. The head of the household selected a taco, his wife decided on a tamale, and their young daughter requested a bowl of posole and a burrito.

"Not all that food before dinner, young lady," admonished her mother.

"Mom, this *is* dinner!" The youngster bit into the enormous burrito and its savory juices dribbled down her chin.

Children flocked around the antique popcorn wagon. A tiny Indian child

clung tightly to her father's hand, and in her other small fist she clutched with equal tenacity a large paper cone topped with pink cotton candy. Not certain how this delicacy should be tasted, she plunged her entire face into the pink fluff, emerging from the cloud with hair-fine sticky strands clinging with a certain daintiness to her delicate copper features and long, full eyelashes. Her father, his black hair bound in the long traditional braids of the Pueblo people, knelt before her and shook his head, a smile playing about his mouth.

"Ja-a we pide, navi-aa," he said in Tewa, gently wiping the sugary mess from his daughter's face with a handkerchief.

An eye-catching duo captured the attention of strollers in the crowded plaza. A large multicolored parrot was perched on the shoulder of its owner, a youth who himself was turned out in a array of flamboyant colors. A vivid red and yellow dashiki, yellow denim trousers with an abundance of tattered fringe at the cuffs, and handmade sandals with wide leather straps and brass fastenings constituted his outfit, and a red headband circled his forehead. Owner and feathered companion moved to a food booth that featured hamburgers, patiently waiting their turn.

"Grawwwk!" With his huge beak, the parrot nuzzled the neck of his owner.

"Right, mate. One hamburger, please. Just the meat, lettuce, tomato, and plenty of spread on the buns. No green chile or onions. He doesn't fancy green chile and onions, do ya, mate? But he's fond of the rest." The accent was decidedly Liverpudlian.

At work at Fort Marcy Park a few blocks north of the plaza, members of the Santa Fe Downtown Kiwanis Club made last-minute adjustments to the ugly, comical effigy that loomed in grotesque majesty more than forty feet above them. From his lofty perch at the top of the steps to the park, Zozobra, Old Man Gloom, glowered down at the already packed spectator area. Workers, unseen by the crowd, pulled ropes to test the flexibility of the monster's arm. It moved upward in a bizarre salute. A shout went up from the crowd, and occupants of the cars parked on the sides of the narrow roads surrounding the park leaned on horns blaring their approval, then resumed their tailgate picnics prepared for the occasion.

In homes that topped the surrounding foothills and provided a private viewing for the Friday night burning, "Zozobra parties" were well underway. Farolitos lined flat adobe rooftops and driveways. Indoors, and on patios festooned with bright red chile ristras, party guests glowed, too. They consumed salty margaritas and tequila sunrises and nibbled on slightly more exotic cuisine than was offered at the food booths on the plaza: bite-sized morsels of carne adovada on toothpicks, finger tacos, chile con queso, barbecued chicken wings, and the requisite guacamole dip and salsa with chips.

A tall blonde woman emerged from a low, rambling adobe house on a side street off Washington Avenue. She was striking in a white strapless sundress and

Will Shuster designed the sheet music cover for Billy Palou's Santa Fe Fiesta Song. (Spanish lyrics by Johnny Valdes, English lyrics by Avalee Turner.)

"barefoot" sandals that accentuated her deep tan. Nuggets of rich, webbed turquoise on silver loops dangled from her ears and studded the wide silver bracelets on her wrists. She urged an entire party to abandon the festivities indoors.

"If we don't get a move on, we'll miss it!" she implored, and at her prodding a group of party folk garbed in everything from tuxedos to togas to tutus straggled out the door and down the walk lined with low-burning luminarias. The acrid sweet aroma from burning piñon logs and the spicy scents of Arpege and Chanel trailed after the guests and lingered pleasantly on the evening air as they hurried to join the crowd moving north to the park.

Dusk approached. The plaza became less crowded, the lines at the food booths shortened. A red-yellow-blue-green-garbed kaleidoscope gaggle of Fiestaphiles gradually began its annual movement up Washington Street, past the federal courthouse and the pink Scottish Rite Temple.

The towering figure of Zozobra, with his massive mop of shredded paper hair, his painted frying pan eyes, his pointed, question-mark outlined ears, enormous bowtie, buttons, and cumberbund, and his long white gown, dominated the park.

It was not possible to look upon any isolated part of this Gargantua: the huge, imposing effigy commanded attention to his totality.

His faithful believers continued to stream into the park, and Zozobra scowled down at them with a pouty, mocking mien. His lower jaw dropped open wide and a hoarse, deep-throated growl boomed from its ugly maw—certain portent of his imminent demise. As the evening skies darkened, the crowd waited, eager to cheer the Old Man's burning and the agony of his death throes—to raise the noise level of an entire community's party to an ear-splitting roar.

Although the number of people already packed into the spectator area at Fort Marcy Park and those additional hundreds approaching it would seem to attest to the fact that the entire population had descended upon the northern quadrant of the city, in reality that was not the case. Elsewhere, Fiesta-related activities involving large and small groups were in progress. At their homes, the Fiesta Queen and members of her Royal Court donned their long, white, formal gowns in anticipation of their crowning and enthronement on the plaza later in the evening, after Zozobra's burning.

At the Santa Fe Community Theater, cast members applied makeup and put on their costumes for the 9:30 performance of the Fiesta Melodrama. "The Startling Saga of a Sinister Senator" or "A Tale of T.E.A. and C.A.K.E." poked satirical fun in 1968 at the governor of New Mexico, the state legislature, the education associations, the news media, and a hapless soul who lost the city's time capsule.

There were children in Santa Fe on the first night of Fiesta who preferred to miss Zozobra, stay at home and ready themselves and their pets for Saturday's

Desfile de los Niños—the Children's Pet and Costume Parade.

Preparations for another parade scheduled for Monday were underway as well. Some entries for the *Desfile de Fiesta,* or General Fiesta Parade, required several days' work. The "Historical-Hysterical Parade" promised as usual to entertain and amuse with wildly decorated floats, some carrying prominent Santa Fe citizens in outrageous costumes enacting spoofs on local and national events.

In a small adobe home on Apodaca Hill off Canyon Road, the diminutive, wrinkled lady of the house checked the contents of the pots on her old-fashioned gas stove: green chile stew for Juan, her eldest son; red chile with generous chunks of pork for Ramón, but of course everyone would have some. Her special homemade tamales, ready to steam, for Patricio. Her daughters could be counted on to bring coleslaw, potato salad, and corn-on-the-cob—gringo food.

She glanced at the heaping plate of biscochitos on the wooden kitchen table—they were for Antonio, her baby, even though he wasn't here. He was off fighting a war in some distant, terrible place called Vietnam. She smiled, remembering past parties in this very kitchen, when Antonio could make her biscochitos disappear as fast as magic. She removed her apron, went into the living room and knelt before an ancient wooden santo of Saint Anthony. She crossed herself and prayed silently for her family and especially for the safety of Antonio, so far away.

The men portraying General Don Diego de Vargas and his staff had three days of important activities and duties ahead of them. In fact, at 6:30 that morning they had attended the De Vargas Memorial Mass at Rosario Chapel, honoring Our Lady of the Conquest—La Conquistadora. Splendid in velvet, brocade, and satin, the rich attire of their ancestors, the recreators had gathered for the blessing of the four-day Fiesta and to hear the proclamation which reminded participants that Fiesta was originally a religious observance. The Entrada (Entry), pageant, and re-enactment of the bloodless reconquest of Santa Fe, the most important of the numerous responsibilities of the De Vargas retinue, was yet to come, on Sunday of Las Fiestas de Santa Fe.

While the De Vargas Mass marked the beginning of the Fiesta's religious observances, the public also anticipated the final demonstration of faith on Sunday evening. Vespers at St. Francis Cathedral followed by the Procession by Candlelight to the Cross of the Martyrs had long been observed as a haunting, beautiful observance of religious simplicity. Hundreds of tapers flickered in the crisp night air as participants walked slowly to the Cross, the monument honoring Franciscan missionaries who brought Christianity to New Mexico.

Another, more pagan Santa Fe tradition waited its turn as the Friday night sky darkened.

At 8:30 precisely the sound of a gong reverberated over the heads of the

Shus with a scale model of Zozobra, ca. late 1950s. Photo by Ernest Knee. Courtesy of Elizabeth Knee.

throng at Fort Marcy Park and echoed off the surrounding foothills. The crowd hushed momentarily. Twelve times the gong rang out. Tom-toms began a slow, ominous cadence. Zozobra growled—a timorous, frightened gargle this time.

The deathwatch began.

For the Father of Zozobra, the man who had conceived the idea of an effigy to be burned and to symbolize, by its burning, the end of care and worries, Fiesta of 1968 was to be his last. His death in February of the following year marked not only the passing of the mortal man, but also the passing of an individual who himself was a symbol to an entire town of all that was fun. He had given Santa Fe a party at Fiesta time for almost four decades.

That this would be his last Fiesta—the last Zozobra—surely did not occur to him. He did not dwell on thoughts of death.

"My dad didn't 'do death' well," his youngest son, John, said of his father. "He mourned the passing of family members and friends only briefly. His grieving was intense, but private. None of our family members 'do death' well, but especially Dad."

For the creator of Zozobra, the business at hand was always to get on with life—to create, to work, to love, to help those who suffered hardship, to be tolerant of fools, to have fun, and to generate fun. Those were his reasons for living.

Up at Fort Marcy Park, the forty-third year of fun called "the burning of Zozobra" was just about to begin.

The malevolent beat of the tom-toms was relentless, pervasive. Figures shrouded in white, small "glooms," suddenly appeared and gathered at the base of the monster, circling him, bowing, paying homage. Zozobra's arms moved upward. He groaned, and tortured, inhuman protests issued from his twisted mouth. Dry tumbleweeds stacked around him burst into flame. The "glooms" circled again, paid homage once more, and broke their formation to scurry into the crowd of spectators.

A figure costumed in red from head to foot, torso gyrating, leaped toward the giant. The figure snaked his lean body around the hem of the effigy's white skirt, a writhing, undulating enemy to the Old Man, a teasing foe. The Fire Dancer moved closer to the figure, nimble feet flying, then slowed his dance movements.

Up the steps once more! The dancer's red silhouette was tall, straining toward the figure in white. He disappeared for a heart-catching moment, reappeared, a torch in one hand. He stood still again, head thrown back, poised, prolonging Zozobra's agony.

The crowd began to chant. "Burn! Burn! Burn him! Burn!" As though

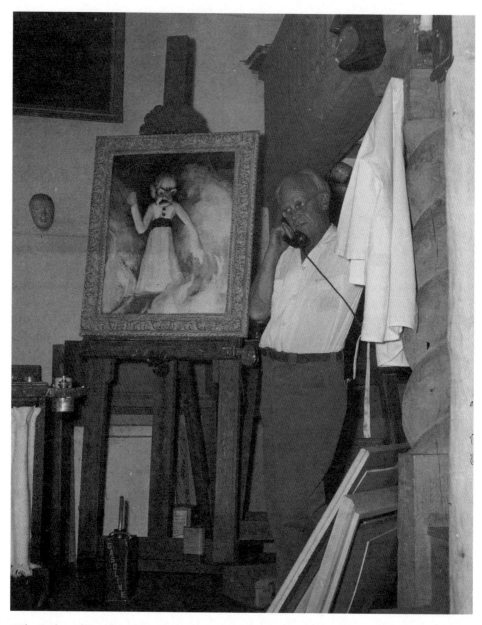

"The Father of Zozobra" in his camino studio in the early 1960s with one of his paintings of his most famous creation.

rehearsed, in perfect time, the crowd exhorted the Fire Dancer to set fire to Zozobra.

Old Man Gloom lifted his arms high, his great jaw sagged, and the abyss of his mouth began to glow from within as his groans became prolonged, tortured screams for mercy. The dancer arced his torch in slow, wide circles, again and again extending his instrument of death. "Burn! Burn! Burn him! Burn!" Spits of flame licked upward. Fireworks burst from Zozobra's head. His wood, muslin, and paper frame ignited into a fiery fountain of Roman candles, cascading sparks of every hue and size. He became a pyrotechnical inferno that signaled the population of Santa Fe to roar and scream and bellow and holler and blare horns in a cacophonous din of appreciation for the grandest bonfire ever and the end of Old Man Gloom. The oldest community celebration in the United States had begun.

A short time later, Zozobra reduced to a chicken-wire frame, the crowd began its snail's pace exodus from Fort Marcy Park to fill the plaza and pack the bars at La Fonda and the Palace and every other watering hole in Santa Fe. Elsewhere in the town there were parties planned and unplanned—parties to crash and parties to start. Will Shuster's diary entry of the next day summarized his Fiesta:

ZOZOBRA came off well—later party at house . . . it developed into a pleasant conversational party evidently enjoyed by all. We retired about 1:30.

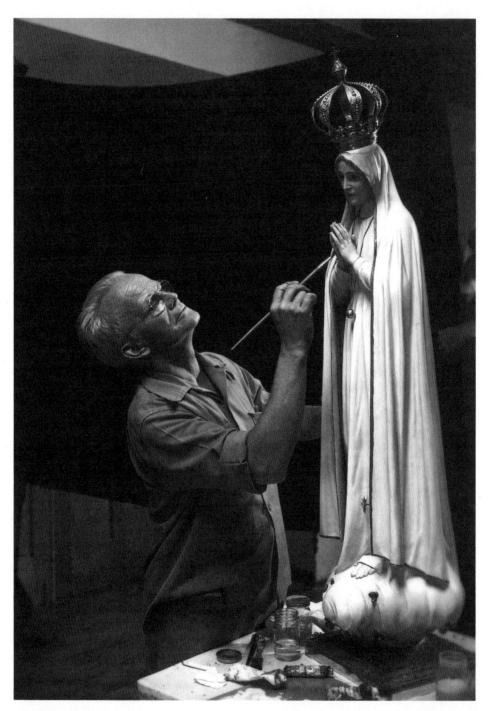

The artist as community servant: Shus restoring the statue of the Virgin Mary (Our Lady of Fatima) in 1950. Photo by Tyler Dingee (his brother-in-law). Photo Archives, Museum of New Mexico.

8

The Shuster Legacy

Art is the flowering of humanity. It embellishes life and reveals timelessly the nature of the plant on which it grew.

In January 1950 Will Shuster brought home the gold. More accurately, he brought back to Santa Fe the National Award for a float he had designed and entered in the Pasadena Tournament of Roses Parade. "Zozobra's flame-spouting visage formed the bow of the 40-foot float," said the Santa Fe *New Mexican*.

> [It was] 20 feet at the widest and rose to the maximum permitted height of 15 feet. Miss Anita Romero, beauteous queen of the 237th Santa Fe Fiesta, adorned the throne which dominated the design. New Mexico's state symbol done in white and yellow mums, with the greeting Hasta La Vista, backgrounded the pretty queen and her co-partners on the dais, Fray Angelico Chavez, representing the Franciscan padres of yore, and Diego Gonzales, who was trapped out in brass and plumes as the famed Don Diego de Vargas.

Taos Indian hoop dancers added more color to the float, which was seen by a million and a half spectators along the long parade route down Colorado Boulevard in the Los Angeles suburb.

It was only one of the dozens of contributions Will Shuster made to the city of Santa Fe. Over the years since his arrival in the adobe city he had given as much back to its culture and traditions as he had absorbed. Among Shuster's salient traits was an unflagging generosity to the citizens of the town he loved. He is honored for those gifts by a bronze plaque in the walk on Lincoln Avenue

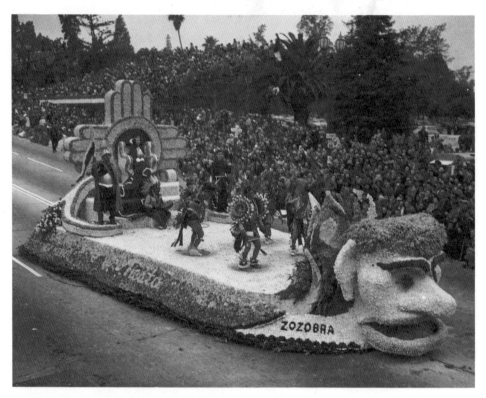

Pasadena Tournament of Roses Parade National Trophy Award-winning float—The New Mexico entry—designed and executed by Will Shuster in 1950.

at the side of the Museum of New Mexico.

Though an artist and therefore a solitary creator, he possessed an endearing affection for people. Men and women alike felt the embrace of his practically indiscriminate friendliness. There was about him a strong sense of inclusion—anyone who came into his circle was to be added to the joyful process of living.

Parties began when Shus stepped into the room. No group, whether serious or silly, artistic or civic, was begun without his participation. He was always inscribed on the lists of poets, painters, public servants, sculptors, muralists, inventors, journalists, and speakers.

What he left behind, especially in Santa Fe, were numerous artistic signposts, evidence that he had been here and had contributed to the lifeblood of the community. His gifts to the city and its people were remarkably various and spanned the entire breadth of the nearly half century that he lived here.

Some aspects of the Shuster legacy relate to his art in itself and some to the art that he applied specifically to civic projects. Other aspects of that legacy are what he left behind as a person, the lessons of his approach to living.

Shuster had the heart and hand of an artist and the mind of an inventor. He was, in a very real sense, larger than any of the single areas to which he set him-

self. The paintings are well-observed scenes from life, without a trace of academic forcing. They are original, both in execution and in their subject matter. Surely the influence of John Sloan was a major impetus and turning point in Shuster's life and art—Sloan, who insisted with single-minded strictness on the idea of depicting what the artist truly saw, nothing more, but nothing less.

Even within that context Shus took originality another step. He captured on canvas—and in the several other media that he worked—subjects that Sloan, for one, did not pursue, such as the caves at Carlsbad Caverns. Much of his earliest painting is portraiture, to which he was drawn not merely for the commissions but out of his sheer love of people.

Versatility was Shuster's overriding artistic attribute. From some of the gentle self-scolding in his letters and diaries, it is clear that he considered it also his artistic shortcoming. He was very good at whatever he turned his hand to, so he complains from time to time that if he were involved with only one thing he might be truly excellent, even great. "One thing," however, was out of the question for Shus. To pursue painting and neglect etching, or to concentrate on etching and drop iron work, would have been unthinkable and, worse, a bore.

Restlessness is a more apt description of his approach to art. Sloan, who rarely deviated from etching and easel oil painting, and some of the Santa Fe painters often pointed out to Shus that dedication to one artistic medium was necessary. But Sloan and the others possessed different personalities.

In addition to painting in oils and water-colors, Shuster executed superb etchings, many of them for his annual Christmas cards, which he made both for personal use and on commission for others. He was a talented wood carver; the gate of his first permanent Santa Fe home at 580 Camino del Monte Sol bears his carving of a dancing Indian figure. He was a fine wrought-iron craftsman. His signature in iron still graces the wall of his second home at 550 on the camino. He was an accomplished muralist; the frescos he did in 1934 and 1943 for the courtyard of the Museum of Fine Arts in Santa Fe retain all their vibrant color more than fifty years later. His murals of Zozobra, at El Nido Restaurant in Tesuque, still attract the admiration of visitors. Life masks in plaster were a favorite Shuster form—not surprisingly, given his genuine interest in people.

He worked in bronze and modeled a prototype for a proposed, but never funded, heroic sculpture in stone for the city's Bataan Memorial. There are references in his diaries to tin work, too, perhaps using Spanish colonial frames and religious articles as models. Sketching and drawing in pencil and charcoal were also part of Shuster's artistic accomplishments.

All the muses, it seemed, smiled on Will Shuster. He was a master storyteller and often involved himself in amateur theatrical presentations. He was a radio raconteur. He played the accordion quite well and sang, two qualities that made him indispensable at the famous social gatherings in and around Santa Fe. His pantomimes were entire intricate one-man shows. Photography appealed to

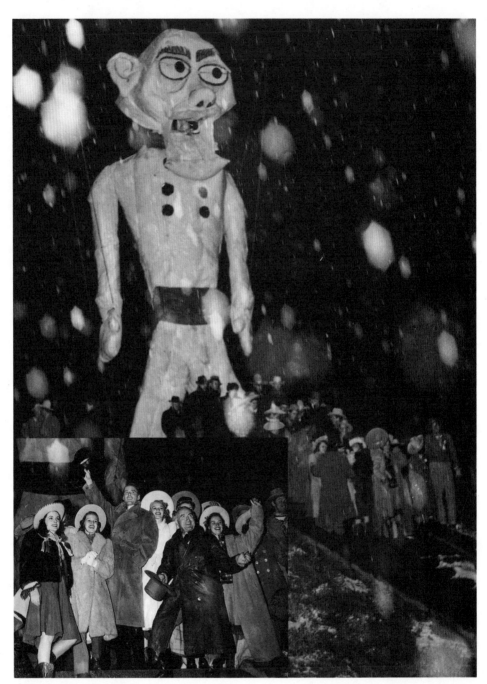

In December of 1940 Shus was asked to recreate the "Burning of Zozobra" for the world premiere of the Warner Brother's movie Santa Fe Trail, *held in Santa Fe. Pictured in the snowstorm are: (left to right) Peggy Diggins, Rita Hayworth, Errol Flynn, Martha O'Driscoll, Donald Crisp, Suzanne Carnahan, and Johnny Weismuller. Absent is Ronald Reagan, who played General George Custer.*

him off and on. And, of course, he was a gifted poet, writer of nonfiction, journalist, diarist, and letter writer.

Shuster never separated art from craft. The creation of the giant bugaboo Zozobra was a natural outgrowth of his art and his genius in making mechanical things work. The much praised Rose Bowl float was another. In 1952 he devised a ferocious-looking bull puppet for a pageant at the Santa Fe Rodeo. El Toro Diablo, whose "eyes flash lightning and whose bellow is deep and fearful as the rolling thunder," made its debut at the rodeo that year in a little play written by Shuster, during which the audience witnessesd "the capture, execution and barbecue" of the mythical bull. Performances of the pageant continue to this day.

In the mid-1950s he was commissioned by the Ohse Meat Products Company of Topeka, Kansas, to design and build a pig along the same lines as the animated Zozobra and El Toro. "Mr. Pig" was operated with push buttons and sound equipment. When he delivered it, Shus told the Topeka *State Journal* with typical cheerfulness, "I can give the guy a pleasant 'oink' or I can have him recite the Gettysburg address. . . . Of course, he'll only be talking about meat products from now on, but this hog is as educated as the guy with the push buttons and microphone."

Shus' invention of piñon and juniper incense was born in the lean and hungry homestead days of the 1930s, but more than a decade went by before Shus actually began manufacturing it. He hit upon the idea out of his desire to use whatever he found for a purpose. The sweet-smelling "scent of the Southwest," as concocted by Shus, was piñon and juniper sawdust with a gummy binder and potassium nitrate. In 1956 he sold the formula and the small incense business that he operated out of his studio for $1,358. Today it is still marketed as a souvenir of Santa Fe and the package still bears his original artwork.

A love of nature manifested itself in Shuster's untiring defense of environmental concerns. In the 1950s he was instrumental in having the banks of the Santa Fe River preserved for the public as Alameda Park. At the time of his death he was engaged in discussions to get Santa Fe Canyon reopened to the people of the city. One of his most important contributions to Santa Fe was his active participation in the Old Santa Fe Association, which is dedicated to preserving the old buildings and the general ambience of the ancient town and to preventing the destruction of historical sites.

Will Shuster was a restless creator who excelled at painting and many other arts. He was also a generous inventor who often gave away what he devised for the good of the community. In 1964, almost four decades after he created the monster puppet, Shus signed all rights to Zozobra over to the Santa Fe Downtown Kiwanis Club. This club still holds exclusive copyright to the figure. It was

Shus putting finishing touches on "El Toro Diablo," the giant bull puppet that he designed and constructed and which made its debut at the 1952 Rodeo de Santa Fe Parade, Pageant, and activities.

a gift outright to the city through that very active service club. Today all proceeds from the Zozobra burning that marks the beginning of the annual Fiesta go to student scholarships and other charitable enterprises.

"He was a genuinely interesting human being," says Harold Gans, president of the Kiwanis Club when Shuster gave Zozobra to it and for many years the groaning voice of Old Man Gloom. "He liked to *do* things, and was uncomfortable just sitting around doing nothing. He was so well known and well loved in Santa Fe that he couldn't walk fifty feet around the plaza without being greeted by fifty people. There was something of a 'character' about him which he cultivated. And Santa Fe accepted him as such—the city has always been a perfect setting for beloved characters like Shus."

John Pen LaFarge, son of poet and novelist Oliver LaFarge, agrees that Shus was a thorough-going character in a Santa Fe where eccentricity was not only acceptable, but desirable. He remembers "Uncle Shus" as a short man with a great shock of wild white hair.

"As a child I used to watch him roll his own cigarettes," Pen LaFarge says. "I was amazed that he was able to lick the cigarette paper and have it stick together perfectly. When I asked Uncle Shus how he managed to do that he said that he kept a cup of glue in one of his back teeth for just that purpose."

LaFarge is a member of the Quien Sabe group, a men's club founded by Shuster and Oliver LaFarge in the late 1940s. The original intent of the organization was to bring artists and other interesting people together—it had begun as the Arts Club. The first members included etcher and printmaker Gustave Baumann, Ira Moskowitz, Ben Wolf, Roy Boynton, and Arthur Musgrave.

What was to have been a forum for civilized discussion along the lines of New York's Century Club became, in short order, an informal social group with everyone talking at the same time and no one listening. It eventually took the name Quien Sabe—Who Knows? in Spanish—to underline some of the club's lighter aspirations. When the club's membership began to reflect the sober values of doctors, lawyers, and other nonartists, Shus hosted a dinner to make a point about the group's original intention: he prepared a hobo supper of mulligan stew and served it in tin cans to his immaculately attired guests.

"Daddy didn't have time to be who he wasn't," remembers his daughter, Linda. "He hated phonies, and he dug his heels in like a mule if someone else tried to make him conform to their idea of what was acceptable. For instance, he never treated me as a girl—he treated me as a person. He valued people for what they were."

"Shus," says Linda, "was sympathetic with people who were struggling to discover themselves. It was a quality he developed out of his own experience. He came to the mountains to die but through a deep personal struggle found life instead."

"He reflected love like a stove," says his son John Adam, "and received affec-

Shus with "Mr. Pig," an animated figure that he designed and built for an advertising display in the mid-1950s.

Shus conceived of and developed a piñon and juniper incense, accompanied by a variety of burners. He also marketed the product in a package that he designed. The first pueblo burner was created for Shus by his close friend Maria Martinez. The "fragrance of the Southwest" is still marketed today.

tion back from it; that's where he got his warmth. What I remember most about him is not a thing or a time, but a tranquillity, a quiet, a nurturing. I had a deep sense of security being around him, a feeling that I was with someone who was very steady.

"Dad and I were the early risers in the house. We would get out of bed and together we would watch the sun come up. Then, as the day began, I would help him make the morning oatmeal."

Don says that more than anything "Shus was more than a parent to me. He was a great friend, a rooting section, and stimulator. He taught by example rather than by dictum. He tried to instill in all of us tolerance and love for your fellow man, an ability to find laughter in any situation no matter how bad it looked at the time. He was a doting, proud grandfather and established a strong bond of friendship with my four sons and to this day is the source of happy memories. I was always awed by his ability to convert an idea or a thought into a reality as he perceived it, in the form of a painting, a poem, or a machine."

A number of people recall Shuster's story of how he came west as an invalid under the death sentence of tuberculosis. He had been told to rest quietly and to refrain from physical exertion of any kind. The time alloted to him in his condition was roughly one year.

Shus later said that he decided, almost with suicidal intent, to hasten his

Shuster finishing murals on the patio of The Museum of Fine Arts in Santa Fe, 1943. The project was begun in 1934.

demise by exercising—for what could be more intolerable for him than simply resting? He walked around town, then he took to walking longer stretches out in the piñon-dotted high desert. Finally he was able to ascend Sun Mountain with a picnic lunch on his back without so much as a shortness of breath. It was the exercise, he said, against the advice of all the doctors he had been to see, that cured him.

He had meant the story as a joke on the doctors and a commentary on the baffling ironies of life. But what emerges is an image of a frail young man with an incurable disease who took on the responsibility for his own recovery and obstinately, patiently, courageously brought himself from the brink of death to full and productive health.

Among the many contributions he made to the people in his circle—and at one time in the Santa Fe of old that included most of the town—was the lesson of applying the joy of life against the ever-present threats of discouragement, depression, and disappointment. He crystallized that lesson on a grand scale in the annual banishment of gloom in the torching of the imaginary bogeyman Zozobra.

But Will Shuster left much more to the cultural heritage of his times. He was a one-man celebration, a consummate artist who reveled in the act of creation and invited everyone around him to participate in the great thrill of making things. In the depth of his artistry and the dazzling diversity of his work, he was a true Renaissance Man—Santa Fe's own legend.

Index